ARCTIC NATIONAL WILDLIFE REFUGE

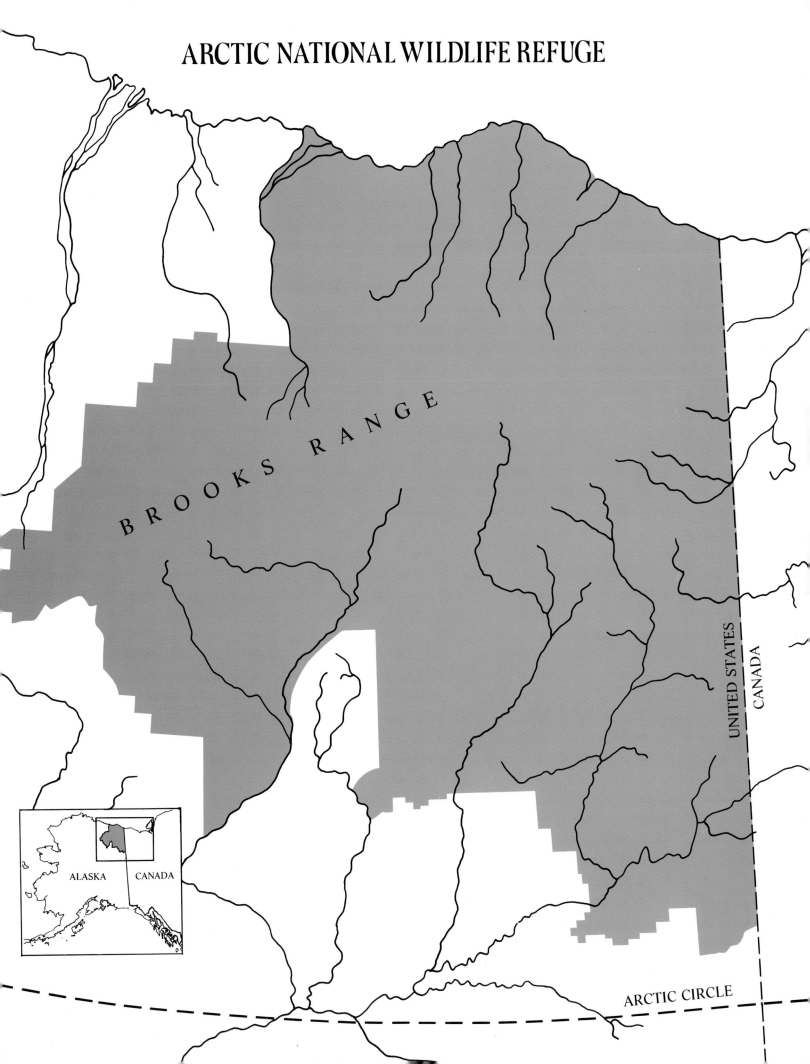

BROOKS RANGE

UNITED STATES

CANADA

ALASKA

CANADA

ARCTIC CIRCLE

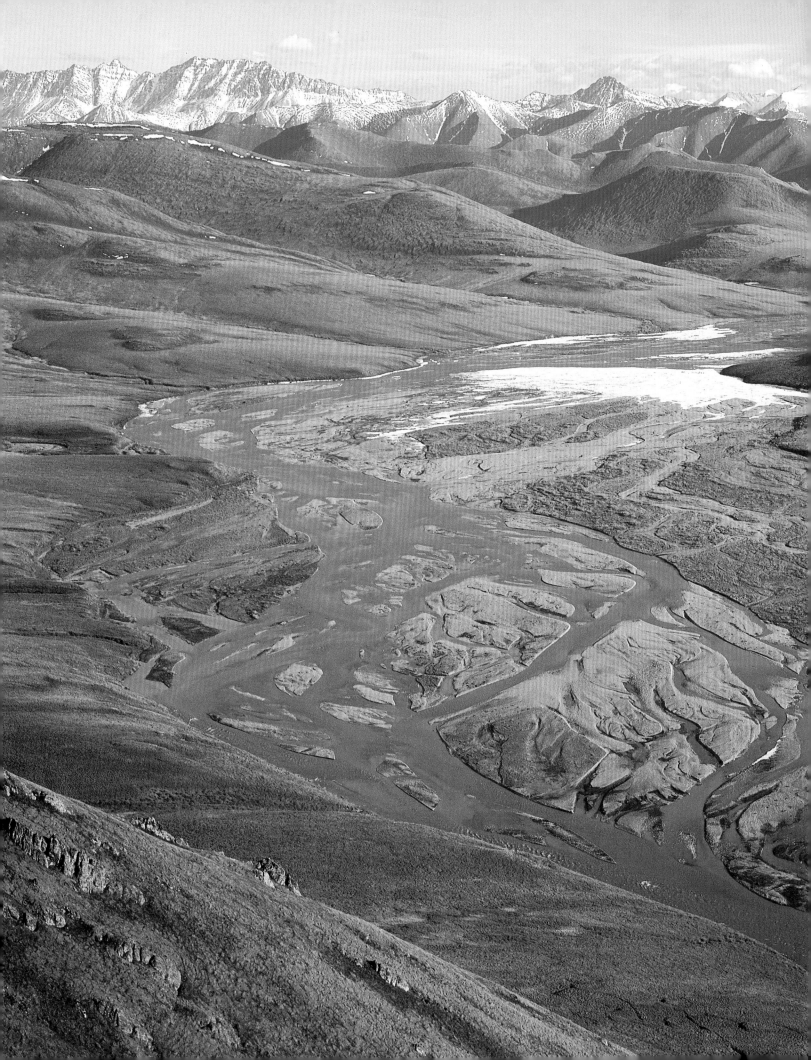

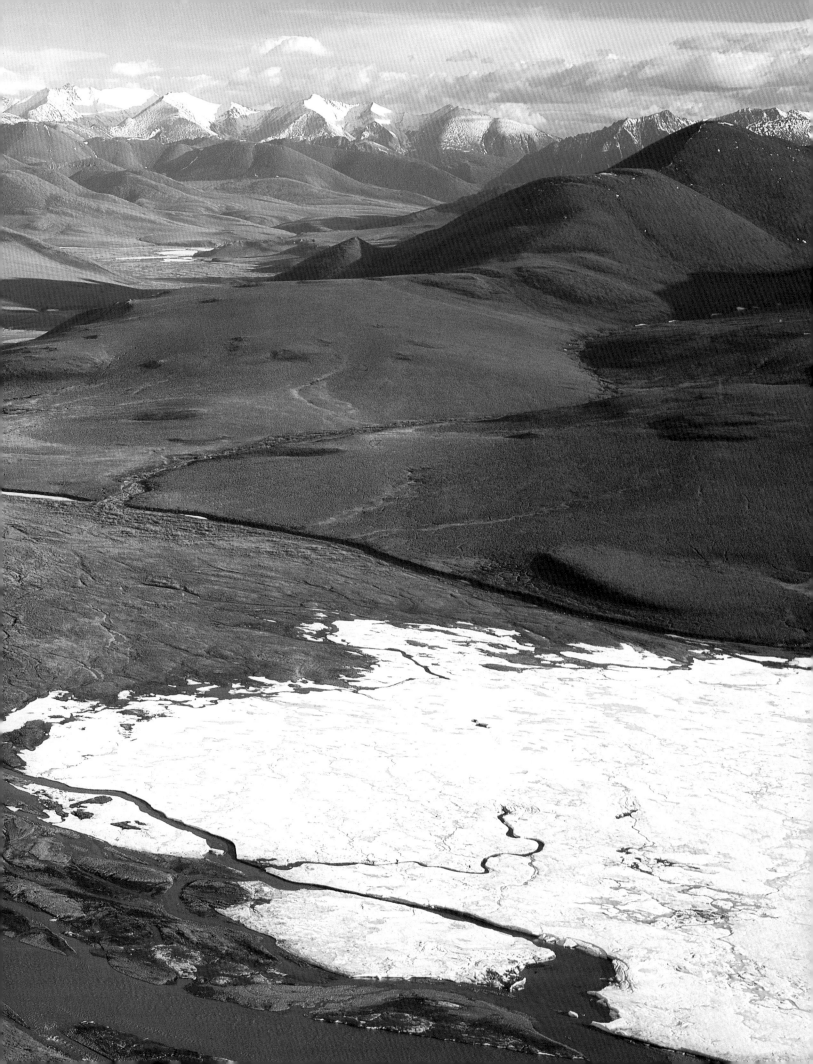

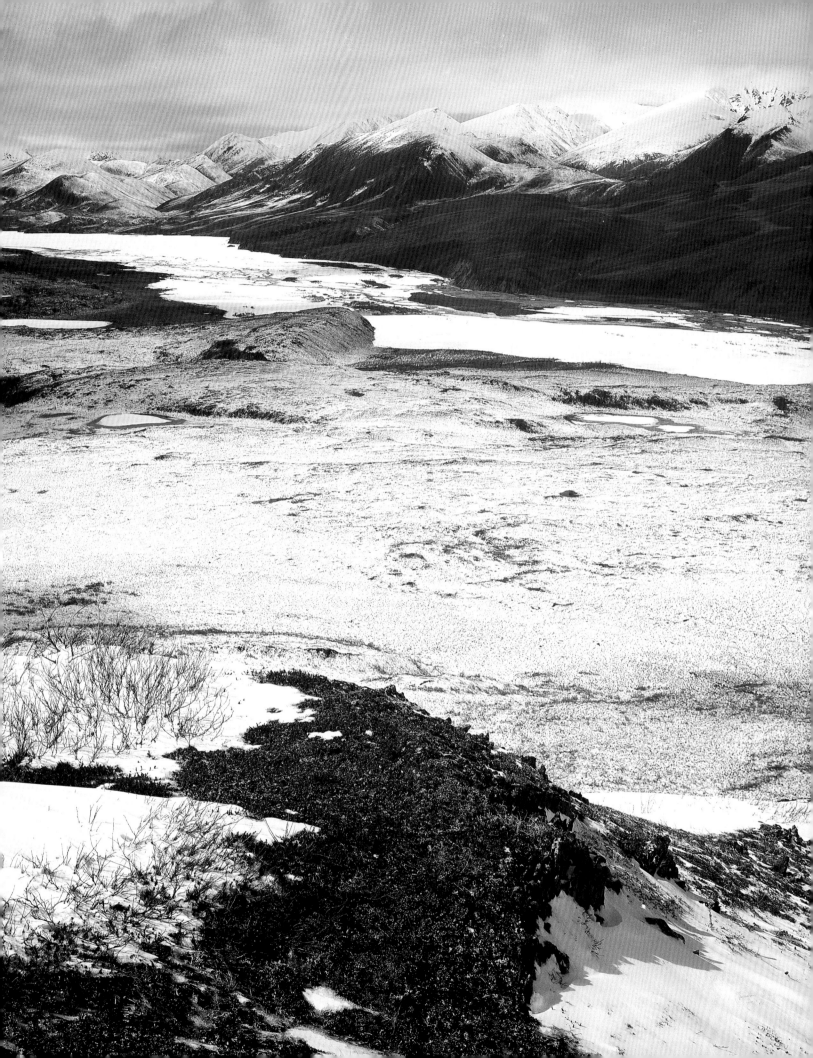

VANISHING ARCTIC

Alaska's National Wildlife Refuge

INTRODUCTION BY
EDWARD HOAGLAND

NARRATIVE BY
T.H. WATKINS

PHOTOGRAPHS BY
WILBUR MILLS AND ART WOLFE

APERTURE
IN ASSOCIATION WITH
The Wilderness Society

The Meaning of Wilderness

BY EDWARD HOAGLAND

Wilderness has a good many meanings. Bitter cold or uncommon danger can make of any patch of the outdoors a "wilderness," but nothing precludes balmy weather from the equation; nor are snakebite and quicksand essential ingredients. My happiest experiences in wilderness landscapes happen to have been in Alaska, and my favorite town there is Fort Yukon, a dot of a place thrown down near the juncture of the Porcupine and Yukon rivers, a few miles north of the Arctic Circle. This was the first English-speaking community in Alaska (1847), a pioneering fur-buyers' site now occupied mostly by Kutchin Indians and still a jumping-off point for winter trapping trips and summer jaunts up the Chandalar, Christian, Porcupine, Black, Sheenjek and other pristine rivers that feed the Yukon. It is surrounded by a huge wet wilderness containing forty thousand lakes that is called the Yukon Flats and is one of the richest breeding regions for waterfowl in the world. Abutting the Brooks Range from the south, it is larger than Massachusetts and Connecticut combined.

I've stayed in Fort Yukon twice, flying in on the mail plane and tenting there long enough to make a few friends and feel at home. So it was natural that when, in the course of writing a novel, I became curious to learn more about Bigfoot (or Brush Man, as the Kutchin call the strange phenomenon), Fort Yukon was the village where I began my inquiries.

Sure, Bigfoot had lived in these river valleys, I was told. A number of people had seen him or knew of circumstantial evidence of his existence. All had heard the stories, as well as others about an odder, perhaps yet more intriguing form of human-oid wild being: the Little People. These tiny but aggressive, quite communicative inhabitants of the taiga and the tundra had prodigious strength and cryptic personalities, living mostly underneath the earth and snow, but contacting human beings more confidently than Bigfoot. They were self-sufficient, for one thing. They didn't need to steal food from a

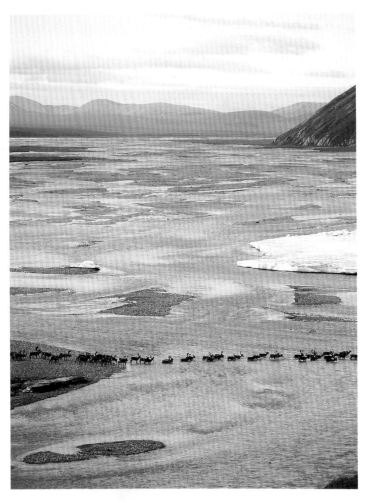

Porcupine caribou herd crossing the Kongakut River.

campsite, as Bigfoot sometimes would, and didn't hunger for the companionship of women either, like Bigfoot occasionally. Although they played quirky and raffish—or sinister and heartless—pranks, they also were capable, when the spirit moved, of doing a good turn: saving a lone traveler's life or extricating him from great danger, if he pled with them. Whenever they proved troublesome, the only way to quiet them was to build bonfires over their burrows, boil pots of water, and threaten to pour that down their holes.

Bigfoot was a kind of howling fugitive, by comparison, an outcast figure apparently in need of fellowship with man at the same time as—glimpsed at the end of trail or across a frozen lake—he fled from him. The sister of a woman I knew had been abducted by a Bigfoot, and all one summer her brother had tracked the two of them, hearing her cries receding in front of him wherever he followed the sounds. Bigfoot was not an insouciant species like the Little People; he might wail with loneliness, or even starve. Some Kutchin believed that instead of being one of the mysteries of Creation, Bigfoot was really a series of exiled Eskimos who had been expelled from their own settlements north of the Brooks Range for murderous crimes or for going mad, before the white man's laws and social agencies had instituted other means of dealing with them.

"Used to be here, that's for sure. *Used* to see him," I was told. "You're a little late. Now you'd probably have to go up north of here, up where the big bears are." My friend, Tom, who was splitting salmon, waved toward where the mountains would be, if we could have seen that far. "And the Little People, too. They don't like the helicopters and the hubbub here. Smoke jumpers. Fisheries men and mining men from Fairbanks, and the ones from Anchorage that fly in and go moose-hunting. Every boat's got a motor on it."

"But you mean they're in the mountains?" I asked him.

"And farther away than that. Way up north. I forget what that place is called where it's so wild. It's a kind of a preserve."

"The Arctic National Wildlife Refuge?" I said.

"Empty place. Yes, that's it. You don't know what you'd find. A place like that might still have some of those wild things."

All across Alaska's vastness, even in other reserves, I heard about the Arctic National Wildlife Refuge as the best and final future place to make a leisurely traverse or enjoy a camping trip that was not rooted in our century. My own handful of days spent on the Killik River, on the north slope of the Brooks Range a little easterly of the ANWR, was like no other interlude in the half-dozen trips I've made to Alaska—the feeling of isolation, surrounded by wild animals that were almost oblivious to me, like the peace of Eden (my time there was of course in the high summer).

The Copper River, way to the south, and the Kuskokwim, considerably southwest; the Tanana and Susitna, both nobly savage, major rivers in the midriff of the state; Admiralty and Akutan islands, 1,240 miles apart; Kotzebue and Nome and Juneau; Point Hope and Tenakee Springs; Bristol Bay; the valley of the Koyukuk; Denali's peak and park—these are all favorite haunts of mine in a treasury of rivers and of ranges that are a wonder of the world, not just this nation. But none of them provides quite such a sense of unknown possibilities as the north side of the jumbled, nameless, magnificent mountains that slope into the coastal plain of the Arctic Ocean, where polar bears cross scent lines with wolverines and wolves and grizzlies, and moose browse on dwarf willow trees, as maybe 200,000 caribou sift through.

Endpapers, Romanzoff Mountains; pages 2–3, British Mountains above the Kongakut River Valley; page 4, June snowfall, Kongakut River; page 6, on the shore of the Beaufort Sea; at right, Eagle Creek Valley.

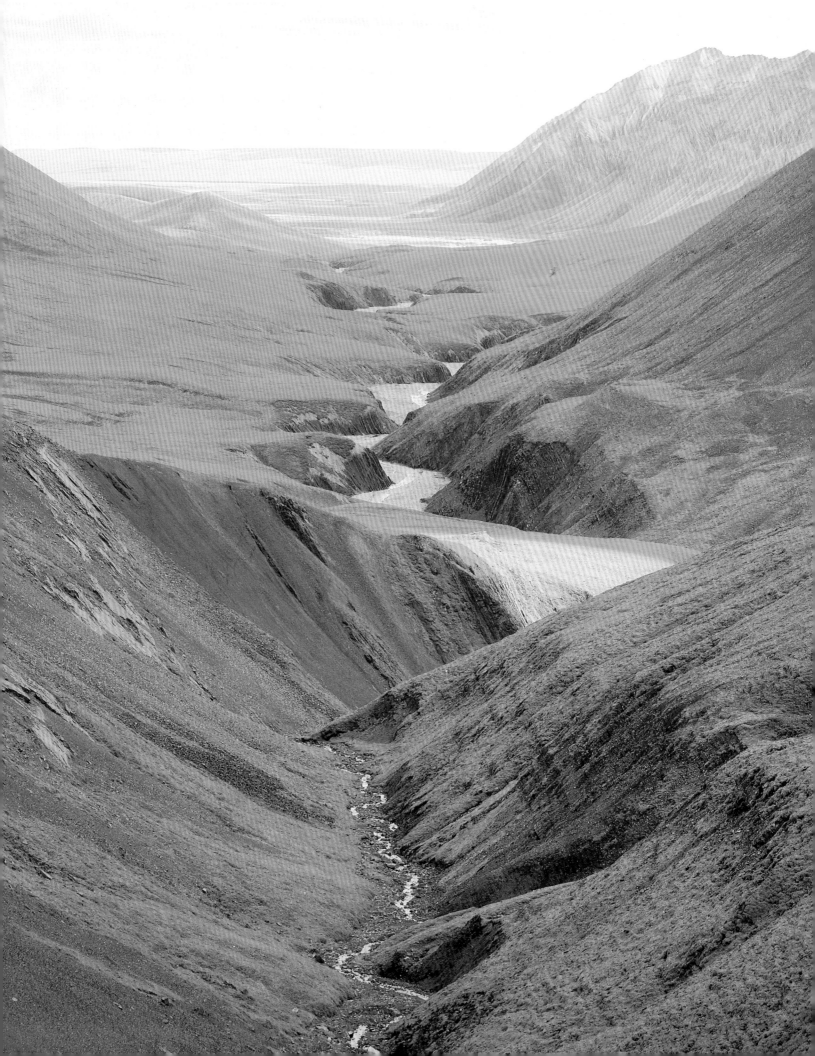

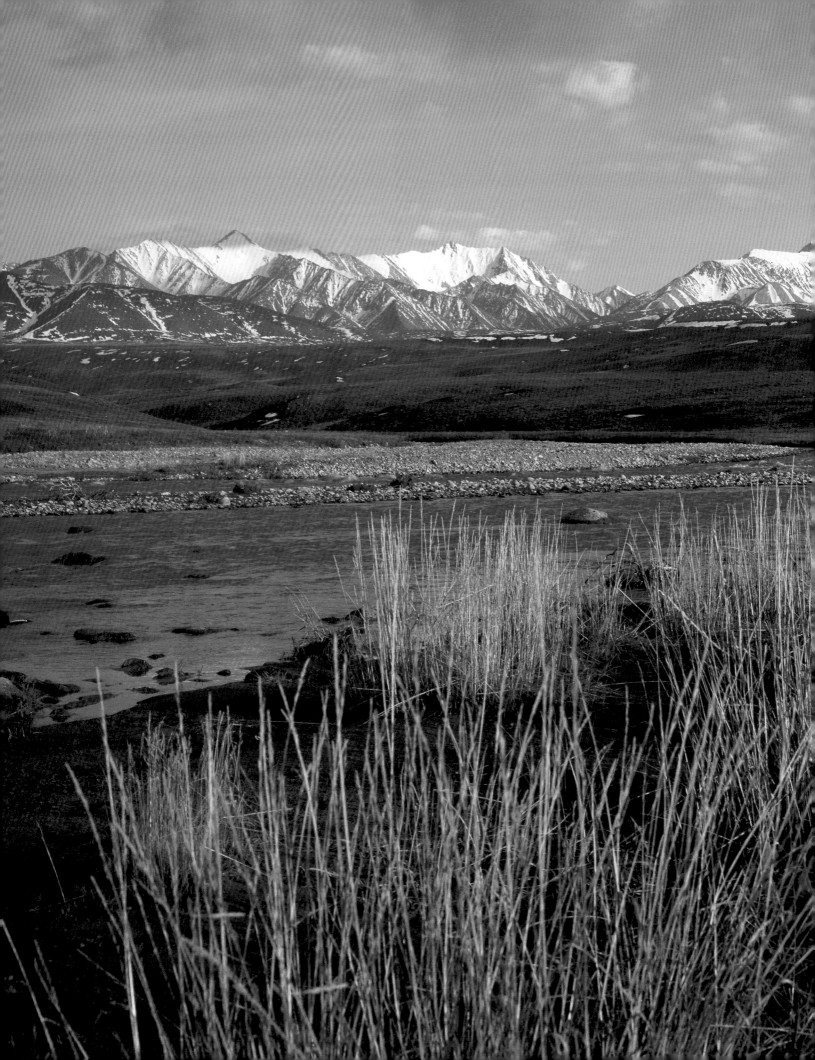

The Fragile Magnificence

LAND, LIFE, AND RISK AT THE TOP OF THE WORLD
ARCTIC NATIONAL WILDLIFE REFUGE

BY T. H. WATKINS

Prologue

THE SUN . . . The sun is primeval in this huge land. It is sun as the earth knew it in the beginning. We stand exposed to its relentless light in a kind of confused fascination. We feel its presence as if we were sunflowers; our bodies turn with it, fill with it, its energy runs through the veins like electricity and bursts to illuminate the mind. It will be with us hour after hour, day after day, reeling through the sky in a great circle of dips and rises, vanishing only when it slides momentarily behind clouds and mountains, even then its presence a spray of light vibrating in the sky.

THE SKY . . . There is no sky like this, none that I have seen anywhere. Blue as the heart of a glacier must be, deep, deep, its farthest reaches almost visibly trembling at the brink of space. Staring into such a sky you can feel the earth move in orbit, feel the passage of stars out toward the place where the universe bends. Through this great blue clarity clouds the size of subcontinents move with ponderous dignity, now piling up against one another in heaving aggregations, now tearing apart in shreds that slowly reform to become pearl-white massifs again, each navigating the sky in stately isolation. Their shadows pass across the shoulders of the mountains like dark caressing hands.

THE MOUNTAINS . . . They stand in rising conical heaps on both sides of the wide, cloud-shadowed valley, rank after rank of them arranged into the distance, their repetition only emphasized by the giants among them—Mount Michelson, Mount Chamberlin, Togak Peak. They are graphically precise, most of them, like exercises on a drafting board. In the right touch of light they can seem two-dimensional, triangles flattened against one another in a casual design that might have been accomplished by a child with scissors, paste, and construction paper. The

shades of the near mountains are soft variations of gray and brown, with a blush of green from the tundra that clings to their slopes, enriched here and there by a darker hue from clumps of dwarf birch and arctic willow. Midsummer winks of punctuation come from the orange of lichen-covered stone, and from the blues and lavenders, reds and pinks, and yellows and whites of dozens of tiny

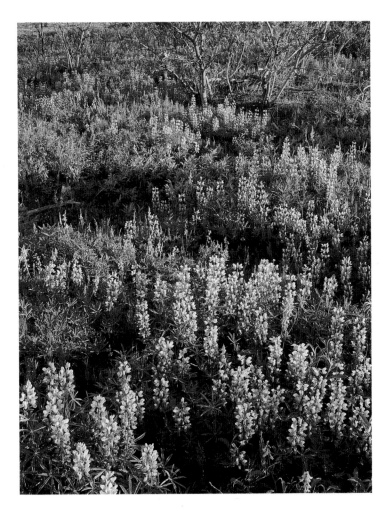

In the land of enormity and detail: at left, the triangular peaks of the Brooks Range rise as a backdrop to the Coastal Plain; at right, lupines blossom near Old Woman Creek in the foothills.

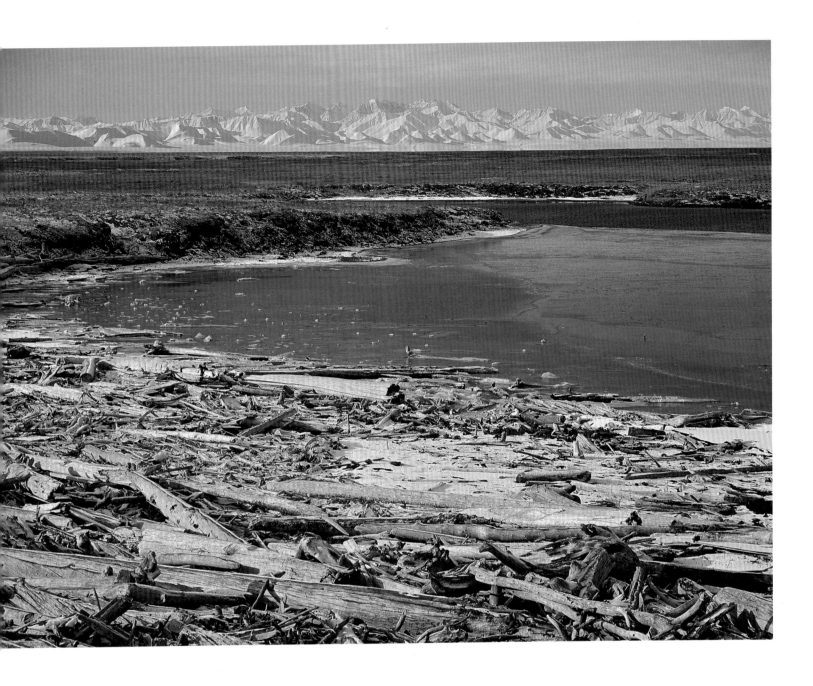

ground-hugging flowers scattered like seeds of color. The Romanzof Mountains, the Franklin Mountains are what they are named, these jumbled walls that bracket the valley, impressive additions to the enormous complex called the Brooks Range. Hidden in and among the high peaks of the farthest distances are packs of glaciers; we cannot see them, but we know that they are there because meltwater from their gravid snouts feeds a hundred thousand trickles that gather to become a thousand rivulets that gather to become a hundred creeks that hurry down the gullies and canyons of the range to feed into the river at our feet.

THE RIVER . . . It grumbles and mutters as it rushes over the harsh and graveled bottom, perhaps seventy-five feet across at this point. Clouded by the ground-up rock called glacial flour, the river is opaque, its eddies and

In a landscape whose summer light both magnifies and clarifies dimension, distance becomes a permanent part of the geography; above, the peaks of the Brooks Range are seen from the edge of the Beaufort Sea, at least forty miles away. On the opposite page, wolf tracks annotate the banks of the Aichilik River, one of the sites where oil companies would dearly love to drill.

riffles like tendrils of aluminum foil when the sun strikes the surface, like coils of lead when the shadows fall. In sun or shadow, there is little in its appearance to match the giddy irreverence of its name—the Hulahula. The name, we are told, comes from the nineteenth century and a Yankee whaling ship that had taken on a crew of Hawaiian natives in the islands before sailing up through the Bering Strait to spend the winter locked in the ice off the river's mouth, waiting for the whales of spring. Nearly a hundred miles south of where they waited we are

camped on the west side of the river on a wide alluvial plain of gravel, stunted willow thickets, and tundra, only three miles north of the point at which the river emerges from a canyon whose head begins just under the lip of the Continental Divide. During the next day we will climb high up the slopes of the mountains behind us to look down and see how the river curves out of that canyon, then braids itself through the valley it has carved from the ancient stone, twisting north through rock gardens and immense glimmering sheets of the overflow river ice called *aufeis*, until it spills out past Kikiktat Mountain and into the Coastal Plain, where it meanders with maddening complexity across forty miles of undulating tundra to the Beaufort Sea. We cannot see this last part of the river's journey from here, but we know of it: this is why we have come.

There are eleven of us. Early this morning, we loaded ourselves and our gear aboard a sleek old DC-3 in Fairbanks and lumbered spectacularly over the Brooks Range to Kaktovik, an austere Native village on Barter Island at the very fringe of the arctic plain. Standing on the island's dusty little strip this afternoon, waiting to be airlifted by bush plane into the mountains over which we have just flown, it was impossible not to stare out across the pack ice of the Beaufort Sea and reflect on the fact that there was nothing between us and the North Pole but more of that challenging whiteness. And the wind, always the wind, an endless gelid reminder of exactly where we were. By bush plane, then, over the many-rivered plain to the mountains and the valley of the Hulahula where we have set up our camp, our tents little explosions of color in the great, muted landscape of this arctic world.

THE ARCTIC . . . Arctic National Wildlife Refuge, to be precise. A land of enormous geometry etched by the cutting edge of light. Implacable, raw, elemental, beautiful. And threatened. It is the threat that brings us here to a gravel bar by the side of an improbably named river to find our way back to the coast by rubber rafts, to see what we can see and package the memories for protection's sake. The threat is a hunger for oil, a hunger that for more than a century had driven those who seek to satisfy it into other landscapes before this one, bringing with them their rigs and drills, roads and roughnecks, laying down fortunes while laying waste, moving on, leaving the names behind them like spoor—Oil Creek, the Los Angeles City Field, the Lima-Indiana Field, the Illinois Field, Spindletop, Red Fork, Glenn Pool, Lost Hills, Signal Hill, Elk Hills, Teapot Dome, a hundred more. One of the newest of them is just a little over a hundred miles west of Kaktovik. The riggers and trucks and technicians haven't left there yet, but, like all the others in most of all the other places, they will leave when the oil is gone, and another name will echo with the hollow memory of their presence: Prudhoe Bay. Before that happens

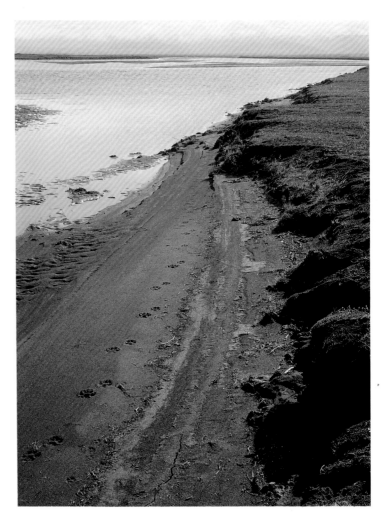

the oil seekers would like to move east, would like to punch a lot of holes and see what they can find beneath the tundra and the permafrost of the Coastal Plain, the rolling brown country between the mountains and the sea. Another Spindletop? Another Prudhoe Bay? Another dry hole? Conservationists—among them this little group patching together a camp on the banks of the Hulahula River deep in the Brooks Range—would like to see them keep the hell out. The conservationists think the Coastal Plain, like the mountains, is part of a whole, unique and irreplaceable, essential to the natural coherence of one of the last great untouched ecosystems left anywhere on earth. They think that to tap into this place—even if the oil is there—would be to damage it beyond redemption.

Oil *versus* wilderness. It is an old story by now, one whose narrative has filled a million pages of documents, has packed pages of books and stuffed the columns of newspapers and magazines, has caused a thousand talking heads to appear on television. But rarely have the lines of discord been drawn with greater exactitude, rarely have the stakes been so high, and never has conflict erupted in a landscape more powerful than the fragile magnificence that lies at the top of the world.

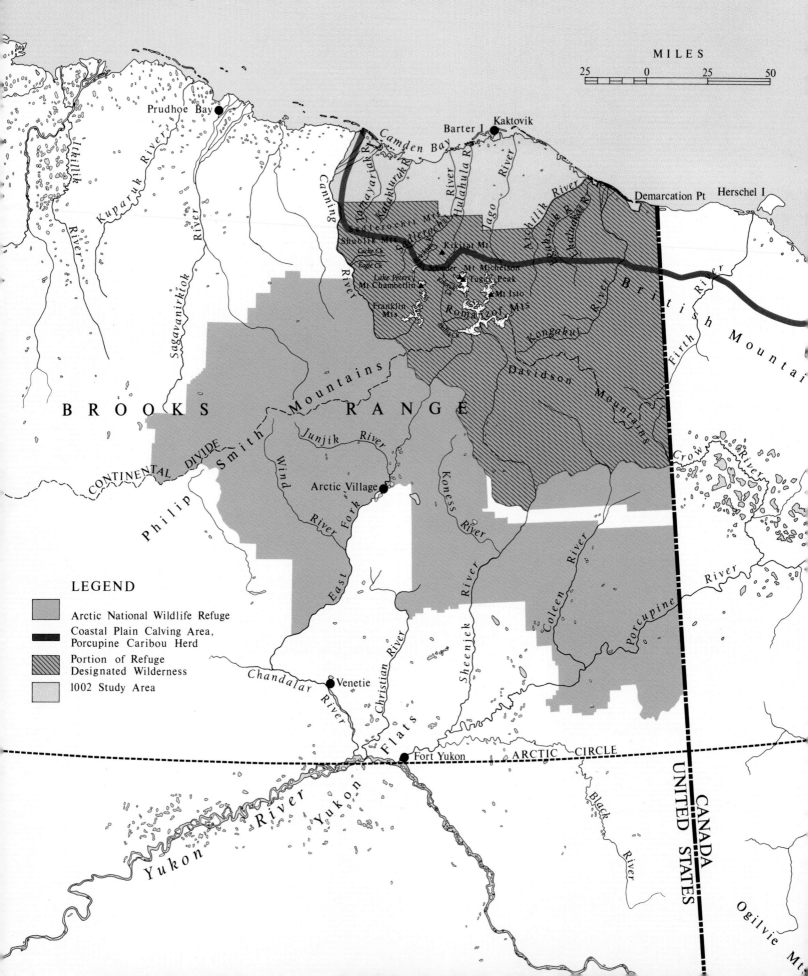

BEAUFORT SEA

N

MILES
25 0 25 50

Prudhoe Bay

Barter I. Kaktovik
Camden Bay
Demarcation Pt Herschel I.

Ikhillik River
Kuparuk River
Sagavanirktok River
Canning River
Tamayariak River
Kaktuvruk River
Hulahula River
Jago River
Aichilik River
Ekaluakat R.
Kongakut River
Firth River
Crow River
British Mountains

Sadlerochit Mts.
Shublik Mts.
Cache Ck.
Eagle Ck.
Lake Peters
Mt Chamberlin
Franklin Mts.
Kikitat Mt.
Mt Michelson
Tugak Peak
Mt Isto
Romanzof Mts.

Davidson Mountains

BROOKS RANGE
Philip Smith Mountains
CONTINENTAL DIVIDE
Junjik River
Wind River
East Fork
Arctic Village
Koness River
Coleen River
Porcupine River

LEGEND

Arctic National Wildlife Refuge

Coastal Plain Calving Area,
Porcupine Caribou Herd

Portion of Refuge
Designated Wilderness

1002 Study Area

Chandalar River
Venetie
Christian River
Sheenjek River
Flats
Fort Yukon ARCTIC CIRCLE
Yukon River
Yukon River
Black River
Ogilvie Mts.

CANADA
UNITED STATES

The Place

Arctic National Wildlife Refuge—known more simply as Arctic Refuge—is the second largest and northernmost of the 437 units in the more than 90 million acres of the National Wildlife Refuge System. Sixteen of those units and 77 million of those acres lie in Alaska; 19,049,236 of those 77 million acres belong to Arctic Refuge. In outline the refuge is a distorted echo of the great fist of Alaska itself, jutting into the state from its northeast corner. Its topmost edge is the coastline of the Beaufort Sea; on the east, it shares a border with Canada's Yukon Territory for 200 miles.

Geologically, Arctic Refuge is the product of time and violence. It began on the floor of the ocean some 350 million years ago, as sediments washed down from two of the planet's original continents—Arctica to the north and Laurentia to the south— and began to accumulate on the bottom of the seaway between them. Then, beginning about 150 million years ago, there ensued a series of wrenching episodes of uplift, intrusion, and deformation, accompanied by much folding, fracturing, and volcanic activity, the whole process resulting in the creation of ancestral mountain ranges that erosion inexorably reduced to hills. About 20 million years ago, another period of violent uplift thrust all this jumble of rock nearly ten thousand feet above sea level once again and brought into sight the beginning of the Brooks Range, the northernmost mountain range in the world—some 600 miles of montane spectacle stretching west from the Mackenzie River watershed of Canada to the shores of Kotzebue Sound, a range containing in its strata and igneous intrusions virtually every known metamorphic and sedimentary rock from pre-Cambrian times to the present. Glaciation from several ice epochs then began to carve and polish the mountains, creating wide, U-shaped alleys,

moraines, cirques, and ridgelines whose edges were like knives against the sky. The range became subdivided into individual mountain complexes—in the region of the future refuge, the Philip Smith Mountains, the Davidson Mountains, the British Mountains, the Romanzof Mountains, the Franklin Mountains, the Shublik Mountains, the

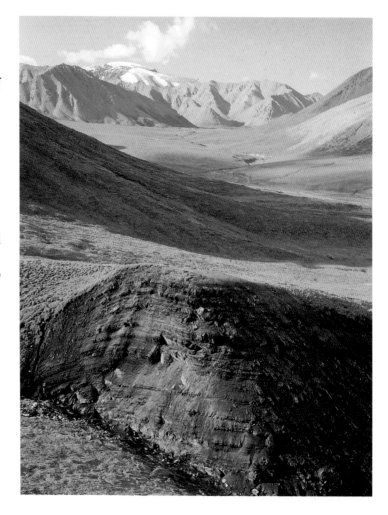

Arctic Refuge, like all places, is in a state of constant change. In the view of the Sadlerochit River Valley at right, ice erosion (solifluction) has caused the soil to slump and move downslope.

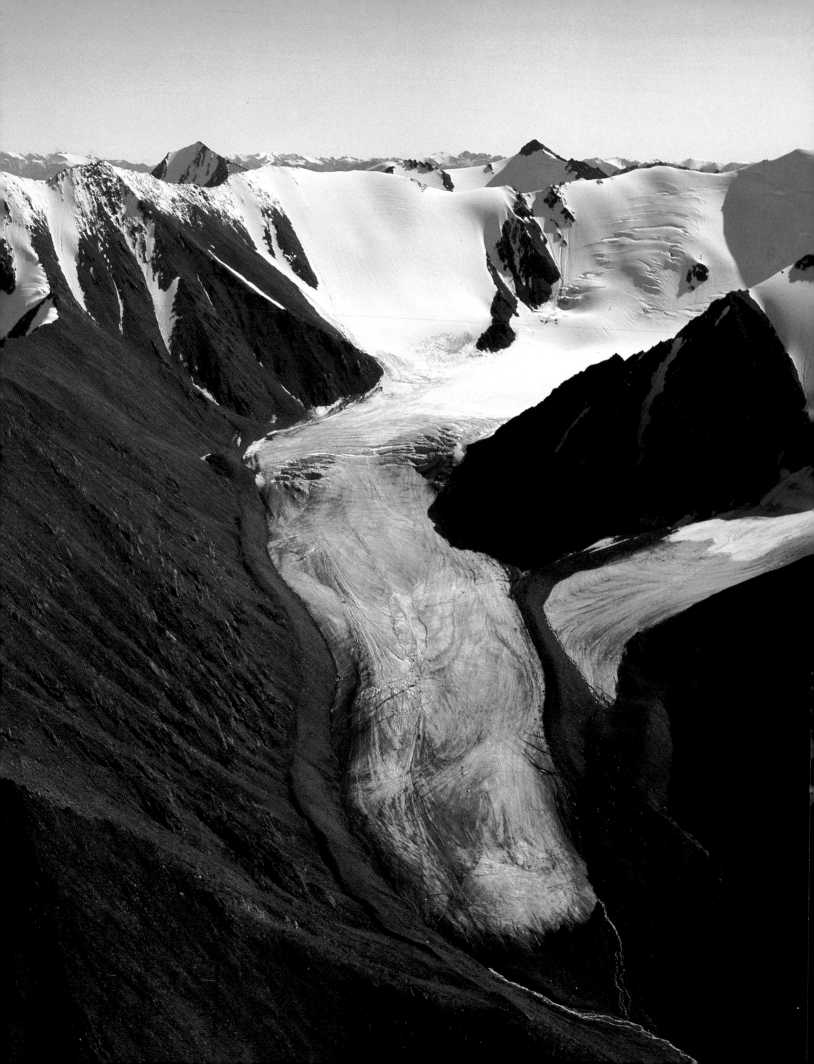

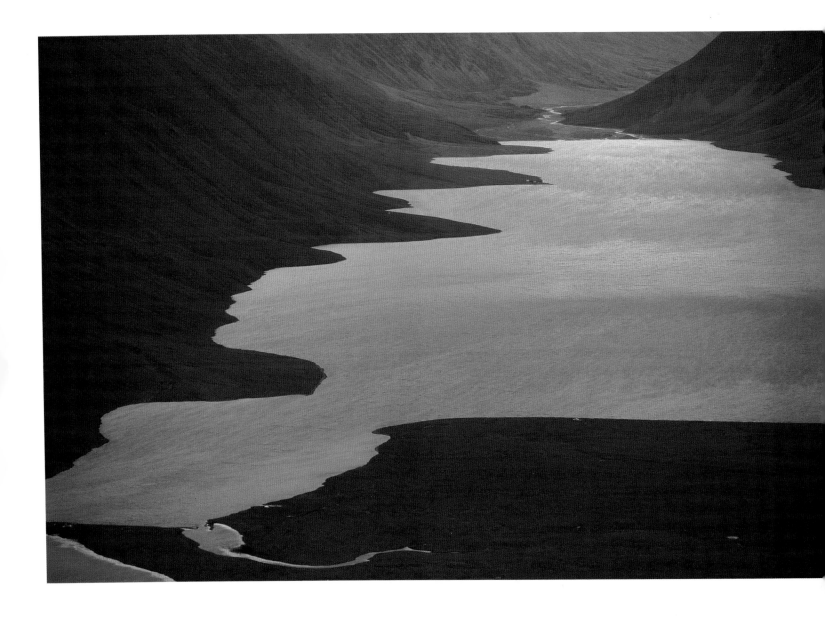

Time and violence gave birth to the Brooks Range and time continues to shape it. At left, the highest glacier in the Romanzof Mountains continues the eons of valley-making; above, Lake Peters, a remnant from another ice age, glimmers darkly in a high valley.

Sadlerochit Mountains. A few peaks jutted up above the average general altitude of 3,800 to 6,000 feet, chief among these Mount Isto (9,050), Mount Chamberlin (9,020), and Mount Michelson (8,855). At least 144 glaciers from the last ice age remain hanging in the saddles, passes, and high mountain valleys.

Water from snowmelt and from the heads of glaciers began trickling down both slopes of the mountains, south into the watershed of the Yukon River, north toward the Beaufort Sea. The trickles became creeks, then streams, and finally rivers that began the great task of tearing down the mountains and carrying them to the oceans. In the south, the principal northern tributaries of the Porcupine River drainage—the Coleen, the Koness, the Sheenjek—and those of the Chandalar—the Junjik, the

Wind, and the East Fork of the Chandalar—contributed their loads of silt to the Yukon River Valley and the Yukon Flats. In the north, the Canning, the Tamayariak, the Katakturuk, the Kekiktuk, the Sadlerochit, the Hulahula, the Okpilak, the Jago, the Aichilik, the Egaksrak, the Ekaluakat, and the Kongakut rivers fanned their loads out into the shallow sea until it filled and became the Coastal Plain we know today.

The twenty-four hour sun that beat down on us on the banks of the Hulahula River is a phenomenon confined to the weeks between early May and early August; after August, the sun begins to slip farther down the sky with every day until, in the dead of winter, the closest thing to sunlight is a crepuscular hint that suggests that there is light somewhere in the world, but provides precious little of it. It is a cold country then: temperatures on the Coastal Plain commonly reach 50 and 60 degrees below zero. In the brief weeks of summer, however, temperatures on the southern slopes of the Brooks Range can

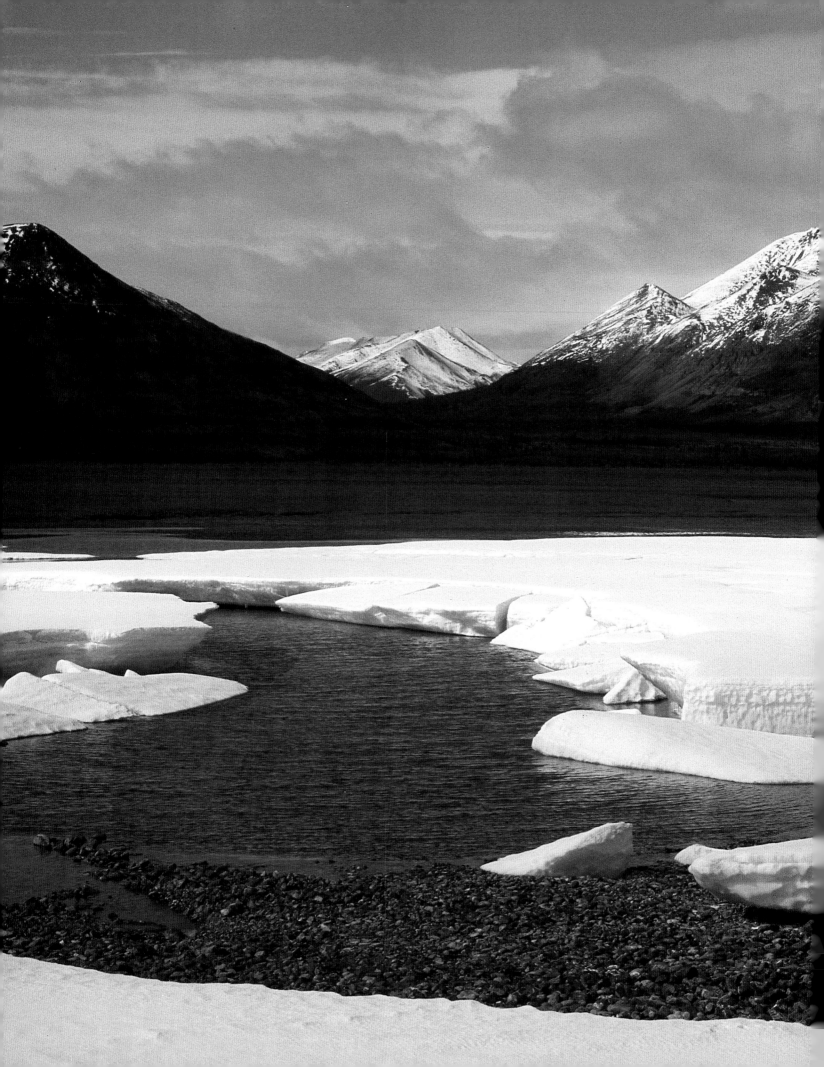

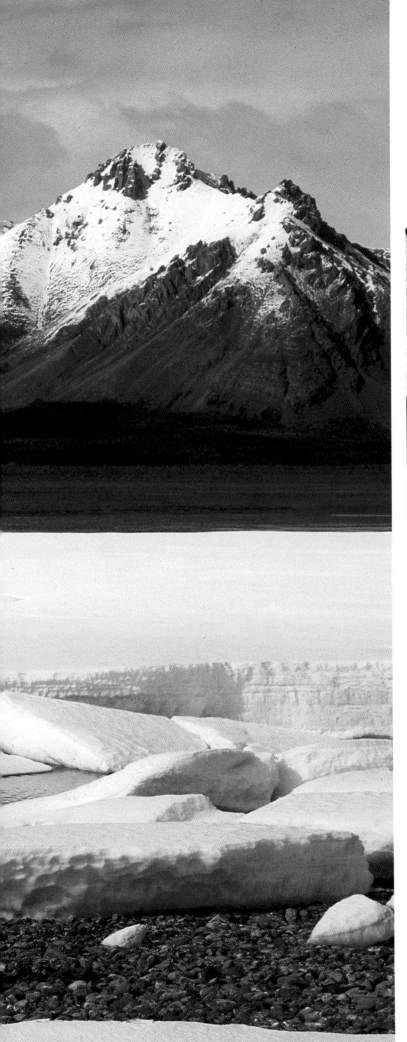

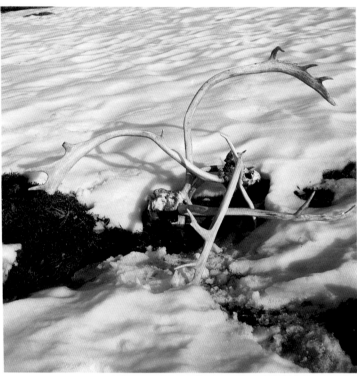

Ice in all its forms is the single
most inescapable fact of Arctic Refuge,
from the glaciers of the mountains to
the permafrost of the plain. One of
its most intriguing forms takes shape as
aufeis, *sheets of permanent ice that
build on the rivers like small glaciers,
as in the scene at left. It is not
uncommon to find caribou antlers, which
are shed yearly by mature bulls, trapped
in the accumulating ice; those above
were discovered along the Canning River.*

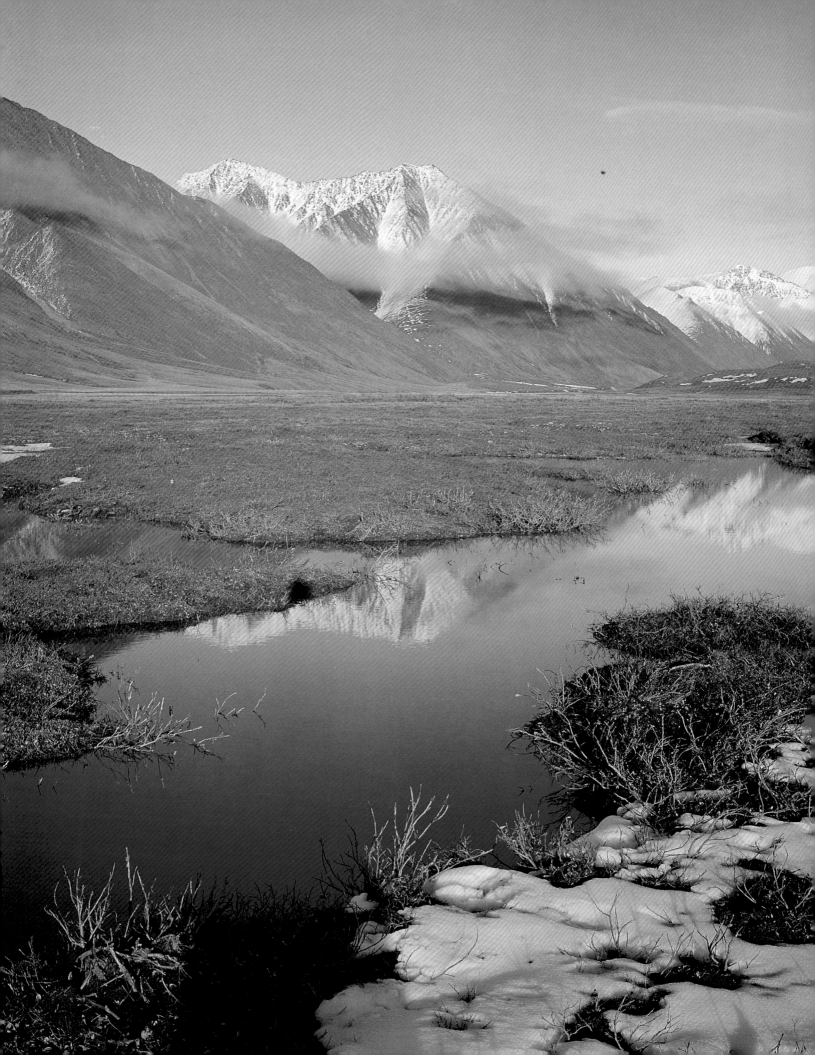

climb into the 80s; and even on the Coastal Plain, with pack ice still shining out on the Beaufort Sea, temperatures into the 60s are not uncommon.

Ice, though, is the true definition of the country, not only the ice of the glaciers hanging in the mountains or the pack ice that sits like a lid on the sea, but *aufeis*, that ancient ice, some of it fifteen or twenty feet thick, which has built up layer by layer, year by year, on the banks of many of the rivers, so thick and persistent that it survives the spring breakup of mid-May; cantilevered shelves of ice are left hanging over the river banks, pieces occasionally breaking off into the streams with great booming sounds. Then there is permafrost, a layer of permanently frozen ground that begins anywhere from four inches to five feet below the surface and extends as much as two thousand feet down in spots. Permafrost prevents the downward percolation of groundwater, so even in the summer it continues to help shape the character of the land by trapping all moisture near the surface and creating widespread systems of bogs, ponds, and lakelets. This is particularly true of the wide expanse of the Coastal Plain, where more than five hundred lakes reach a size of 100 acres or more in especially wet seasons, and thousands of smaller bodies of water dot the landscape as far as can be seen. When this surface water alternates between freeze and thaw, it ''churns'' the earth, loosening it and causing soil and vegetation to creep slowly downhill in a phenomenon called solifluction. In periods of deep freeze, it pries bedrock from mountainsides and in level areas cracks the land into great polygons of crumbly tundra. Standing over a crack at the edge of one of these polygonal slabs, you can hear the uncanny gurgle of hidden water running over the permafrost below.

And yet, if Arctic Refuge were somewhere in southern Arizona, it would be called Sonoran Desert: its precipitation, mostly in the form of snow, averages only six inches a year.

But it is not desert, and because it sits in a transition zone between two distinct North American ecosystems—the northern boreal forest, or taiga, and the arctic tundra—the demands of climate and topography have dictated the evolution of an unusually rich diversity of plant life. On the South Slope, the taiga of central interior Alaska—primarily black and white spruce, with scattered stands of balsam poplar and paper birch, and even some very isolated stands of aspen—reaches its northern limit and dwindles down to various dwarf species as both the

latitude and the altitude increase. Willow thickets border the streams and rivers at almost all elevations on both the South Slope and the North Slope, ranging in height from ten to twelve feet in the valleys of lower elevations to dwarfs only two or three feet tall on the streambanks at higher altitudes (where they are often joined by dwarf birch, and rhododendron). On both slopes, the predominant ground cover is tundra, a thick mat composed mainly of various kinds of grasslike sedges and cottongrass tussocks. On the North Slope, at least at the lower elevations, the tundra often is interspersed with small groves and individual specimens of black and white spruce, giving some areas a parklike appearance. On the North Slope, while it goes from dry to wet as it grows down out of the mountains and on toward the sea, the treeless tundra gives the landscape an appearance reminiscent of the High Plains country of the Lower 48. High or low, dry or wet, however, the unstable knobs of tightly packed cottongrass tussocks make it unshirted hell to walk for any distance.

In the spring and summer weeks, whether among the dark and muted greens of the boreal forest or the straw-like tans of cottongrass plain, there is plenty of color to be discovered, if one adjusts the eye to find it. Lichens are splashed against the rocks like paint from a careless workman. Equally close to the earth, sweet pea, milk vetch, forget-me-nots, lupines, woolly louseworts, Lapland rosebay, avens, cinquefoil, bearberry, wallflowers, dryas, anemones, saxifrage, bluebells, and asters—all spring into life at one time or another during the

Summer brings the everlasting sun, whose presence lights the sky and stirs up the seeds of growth; at left is a look at the valley of the Jago River as seen less than two hours before midnight in June. The most stubborn form of plant life in the Refuge are the various lichens, whose colors are splashed over nearly every rocky surface in sight, from the plain to the peaks. (Overleaf) boreal forest, or taiga, in the valley of the Junjik River, South Slope.

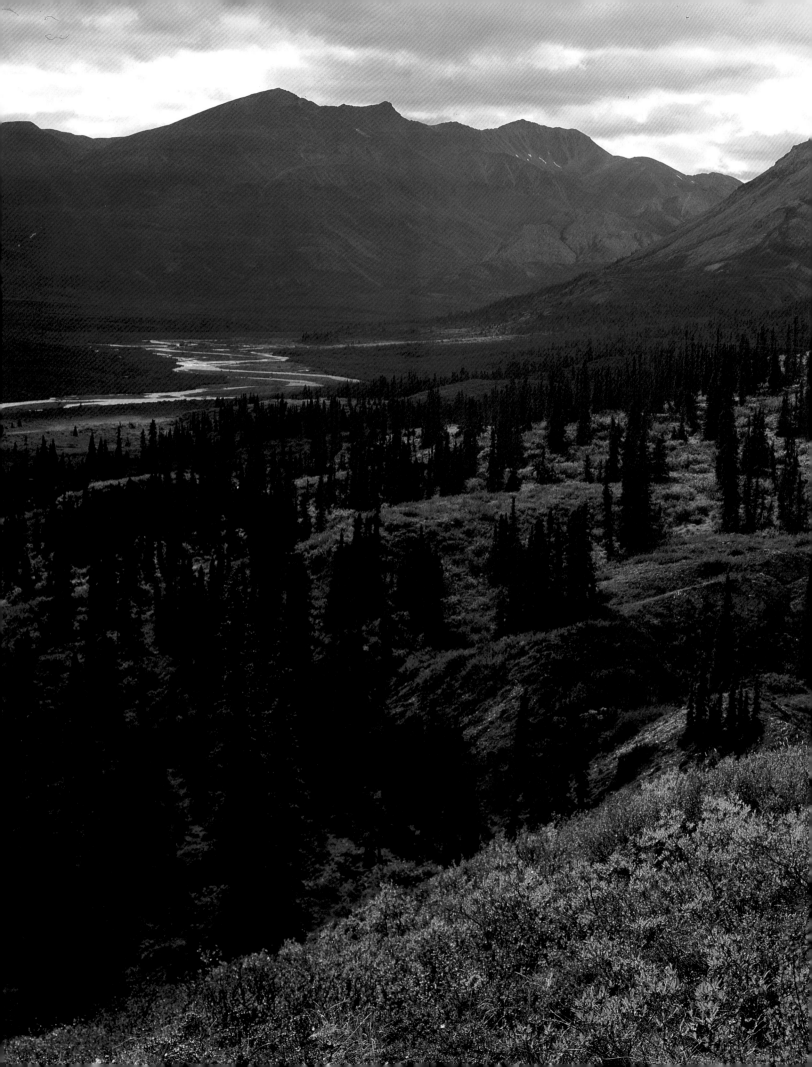

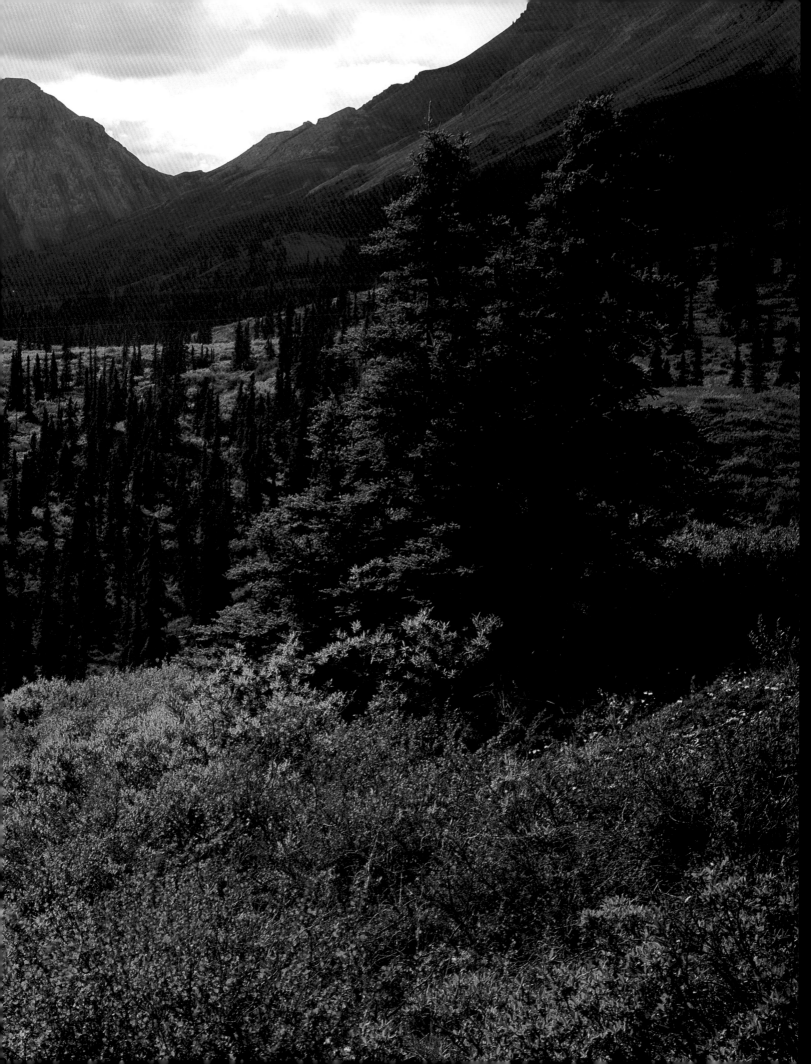

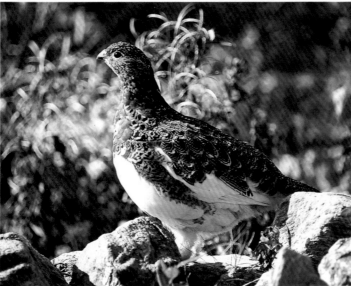

From the cottongrass and tundra of the North Slope to the boggy forests of the South Slope, Arctic Refuge is enriched by a stunning and various collection of life. At the top of this page is a cluster of dwarf fireweed along the Kikiktuk River of the North Slope; directly above is a willow ptarmigan (the Alaska state bird) seen near the Sheenjek River of the South Slope; and on the opposite page, a stand of spruce is shown in the same area.

weeks of sun. The colors from these flowers are not extravagant, but the very delicacy and brevity of their presence gives them an authority comparable to a field of technicolor tulips in a landscape more benign.

There is life and color in the sky, too, particularly in the summer months, for if there is remarkable diversity to be found among the plant communities of this deceptively simple country, the variety and quantity of wildlife—especially the birds—is next to staggering. Arctic Refuge provides the habitat for at least 142 species of birds, millions of which are migrants who return to the Coastal Plain every spring and summer via all the continental and some of the intercontinental flyways: arctic terns all the way from Antarctica at the bottom of the world, golden plovers from Hawaii and South America, wandering tattlers from Ecuador, yellow wagtails from Asia, buff-breasted sandpipers from Africa and India. There are pintails, oldsquaws, and green-winged teals; Canada geese, lesser snow geese, and white-fronted geese; arctic loons and whistling swans; king eiders and bluethroats, jaegers and gulls, black brant and sandpipers, Lapland longspurs, cranes, snowy owls. Along the coast, in any given summer, clouds of birds will be moving east and west—a million king eiders, half a million oldsquaws, 300,000 snowgeese. Among the cliffs and mountain crags of the Brooks Range, gyrfalcons, peregrine falcons, rough-legged hawks, and golden eagles perch and swoop. In streamside thickets and ground-level hideouts, willow ptarmigan and rock ptarmigan perch and scurry. In the valleys of the South Slope, June is alive with the sound of songbirds, some of which move across the mountains to grace portions of the North Slope as well. Only in winter are the wings stilled, the voices silent.

Winter slows down most of the wingless critters, too. Arctic ground squirrels, collared and brown lemmings, and several species of voles are the smallest of the refuge's mammals; a little above them in size (and often in the food chain) are the beavers, otters, martens, mink, lynx, and red foxes of the southern portion of the refuge. Several thousand Dall sheep, which travel in small, separate bands, are scattered through the entire region, most often discerned as white dots drifting and grazing along mountain slopes or cavorting impossibly amid the treacherous crags and cliffs of the higher areas. An unknown number of wolves inhabits both the North and South slopes, hunting over the entire refuge but denning only in the foothills. Wolverines are present throughout the lower elevations, though no one knows how many. Coyote, that ubiquitous North American predator, can be found in the foothills, but normally only on the South Slope, while its little cousin, the arctic fox, is exclusive to the North Slope; it too dens in the foothills, but spends a lot of its time out on the pack ice of the Beaufort Sea, feeding off the carcasses of seals done in by polar bears.

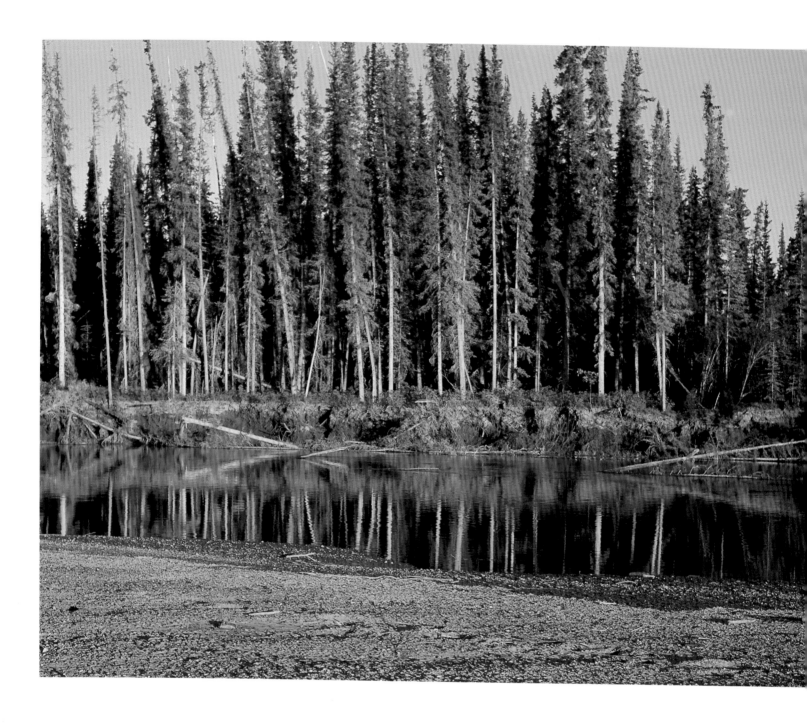

There are three kinds of bears in Arctic Refuge—black, white, and brown, to use the scientific terms. Like all bears anywhere, they will eat just about anything that moves, and a lot that doesn't. The black bear, the smallest of the three, is confined to the boreal forest at the southernmost edge of the refuge. The great white bear—the polar bear—is an inhabitant of the pack ice and its environs, foraging on the ice and along the coastal beaches and denning in the lowlands near the sea; it sometimes wanders inland for as much as ten or twelve miles, however, which would put it well within the range of its only competitor as king critter of the north—the brown bear, or grizzly. The grizzly would consider it no contest; this bear is the largest terrestrial carnivore on earth. No one

knows precisely how many grizzlies inhabit the region but one shirtsleeve estimate has it that in any given year there is roughly one bear for every one hundred square miles of Arctic Refuge; that estimate would provide a little under three hundred animals. North and south, they den on the steep slopes above streams and rivers in late October and early November, coming out in May (the females often with one or more cubs in good years) and moving downslope to forage, feeding on carrion, digging out ground squirrels and roots (whichever comes first) from the tundra, stripping berries where available, grazing the cottongrass tussocks and sedges, scooping grayling and arctic char from the rivers. Enormous hairy eating machines, hunchbacked, their huge clots of muscles writhing

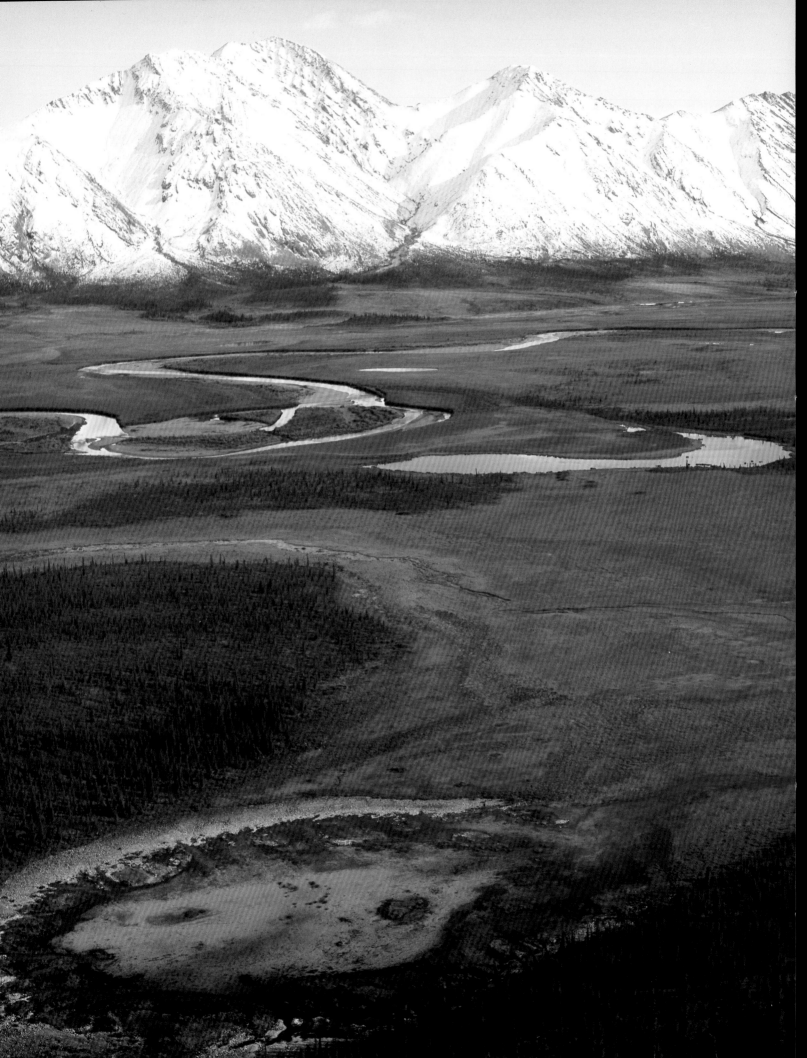

beneath the distinctive tan and brown of their coats, the grizzlies prowl unchallenged over the tundra's hills, fattening for the long winter.

Among their prey are moose, which inhabit the boggy valleys of the South Slope and—in somewhat fewer numbers—the willow thickets of the Coastal Plain on the North Slope, and musk oxen, though it is a rare event for one of these stubby, primeval animals to be pried loose from the tight protective circle that immediately forms whenever a herd feels threatened. Musk oxen were extirpated from the Coastal Plain by hunters in the nineteenth century; reintroduced by 1969 and 1970 by the U.S. Fish and Wildlife Service, they now number about five hundred animals in several individual herds.

While moose are the biggest hoofed mammals, or ungulates, of Arctic Refuge, and musk oxen the rarest, neither by any means is the dominant representative of the order. This distinction belongs entirely to the barrenground caribou, old *Rangifer tarandus*, the creature whose numbers and migratory habits have inspired the

The wetland valleys of the South Slope, like that of the Sheenjek River at the left, provide the best habitat for moose, though moose also are found in the north—as was the family below, photographed in the Kongakut Valley.

catch-phrase description of the Coastal Plain of the North Slope as "America's Serengeti." There are, wildlife biologists estimate, about two hundred thousand animals in the refuge's herd. It is called the Porcupine Herd, because it winters widely in the watershed of the Porcupine River, amid the taiga and protected river valleys of the South Slope of the Brooks Range and in the Ogilvie Mountains of Canada's Yukon Territory. Normally, at the tag-end of every winter, the bulls, pregnant cows, and yearlings turn north by various routes, beginning the trek of hundreds of miles across mountains and rivers to the Coastal Plain of the North Slope, an agonizingly tenacious, plodding migration designed to bring the herd to the coastal areas before the first calves begin to drop. (Though in rare years when the snow is slow in leaving the plain—1987, for example—the herd calves along the migration routes in Canada while moving north.) Once there, most of the herd's calves are born within four or five days of one another, quite often with patches of snow still on the ground. About the middle of June, bands of cows with young calves begin to form ever larger groups, aggregations that reach as many as eighty thousand animals. Feeding on the lichens, grasses, and sedges of the plain, they flow in random movement, like particles in liquid suspension, searching constantly for relief from the bil-

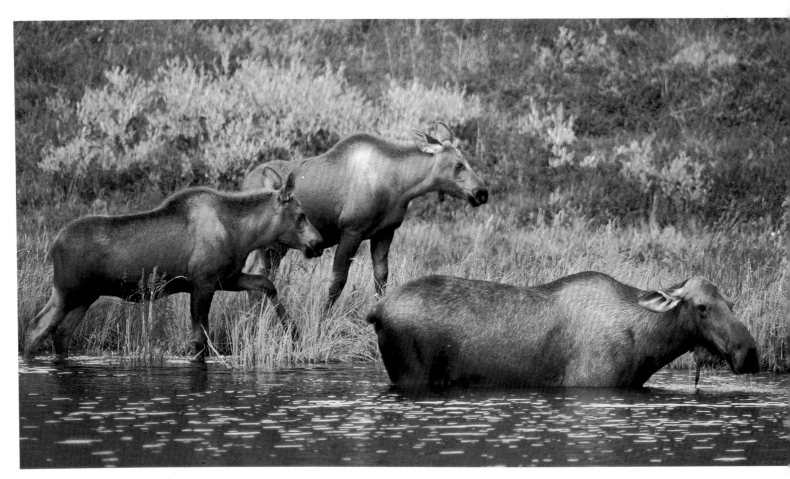

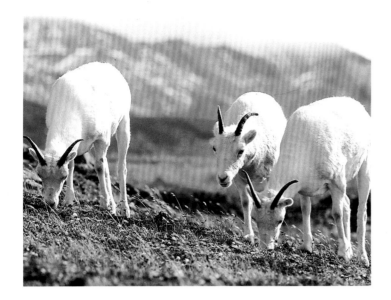

lions of mosquitoes and other insects that torment them. In July, they begin to divide into smaller groupings, then in the fall start moving back across the mountains.

It is a sight not to be forgotten, this migration, the single most powerful natural phenomenon in all the far north of the continent, the one thing above all others that illuminates the majesty of this place and gives it a meaning available to human perception. Listen to Alaskan writer Margaret E. Murie, who first witnessed the migration of the big herd in 1956: "Brina and Olaus and I kept going uphill, trying to get above for a good look, and finally we collapsed on a high slope, on the grass, and settled down to look and listen. They were traveling steadily along, a great mass of dark-brown figures; bulls, cows, calves, yearlings; every combination of coloring, all bathed in the bright golden light of this arctic night. The quiet, unmoving landscape I had scanned so carefully from the ridge before dinner had come alive—alive in a way I am not competent to describe. The rightful owners had returned. Their thousands of hooves, churning through the gravel and water of the creeks and the river, had been the great mysterious 'train' we had heard and puzzled over. Now they added their voices. Individually, the voice is a low or medium 'oink, oink,' very much like that of a big pig. Collectively, they make a permeating, uncanny rumble, almost a roar, not to be likened to anything else I can think of. But the total effect of sound, movement, the sight of those thousands of animals, the clear golden western sky, the last sunlight on the mountain slope, gave one a feeling of being a privileged onlooker at a rare performance—a performance in Nature's own way, in the setting of countless ages, ages before man. How fortunate we were. . . ."

Indeed.

Interlude: On the River

There is a surreal character to distance here, a function of the clarity of air combined with the quality of light. I have seen something like this in high desert country—the contradictory impression you get when everything you see in the distance registers on your mind as the far place it is, but when at the same time you feel an almost visceral certainty that you could reach out and stroke that far place with only the slightest violence to basic physical laws. What is more, you want to do precisely that. It is a seduction, a pull on the heart that reminds me of a line from historian W.H. Hutchinson, describing what it may have been that lured the mountain men of the nineteenth century into the secret promise of the Front Range of the Rockies, "where the roads ran out in trails and the trails ran out in widewashed grass and the wind came down the height of land from the shining nameless peaks whispering 'Come and find me, come and find me.'"

Four of us hear that call—or something very like it—the second day in camp by the Hulahula. After breakfast we strap packs and other equipment to our bodies and set out for the nearest nameless peak to the west, a triangular hump that juts up from the valley floor to an altitude of perhaps 5,000 feet. That will make for a climb of maybe 2,500 feet within a distance of some three miles—a sturdy little hike up to the topmost ridge; afterward, we plan to circle around behind the mountain and come down the other side. I am assured, as the elderly amateur here, that the trek probably will not kill me; I am willing to believe it.

In a few minutes we are out of the graveled area near the river and are walking on the lower edge of a fan of tundra. We reach a stretch of ground that looks as if a backhoe has gone amok—great dark gouges have been scooped out of the earth over an area of two hundred square yards. This is the wreckage left by a grizzly passing through in search of ground squirrels and roots, I am told, and the damage is enough to raise up in the mind half-forgotten stories of bear attacks—Hugh Glass mauled and left to die in the Bridger-Tetons, that sort of thing. A little farther on and we come to a small pile of old wolf scat, and I begin to feel the edge that comes when you know you are in country with animals that can kill you and eat you—the very essence of wildness, in human terms.

The tundra offers us a wide cluster of cottongrass tussocks now, grassy knobs not so tightly packed that they give the foot any kind of reliable support; rather, they wobble treacherously as you step upon them, while you do your best to avoid the foot-grabbing muck that more often than not lies waiting in the interstices between

In the mountain valleys of the Brooks Range, at right, there is something that whispers "Come and find me. . . ." Among those things that can be found are Dall sheep, two of which graze, upper left.

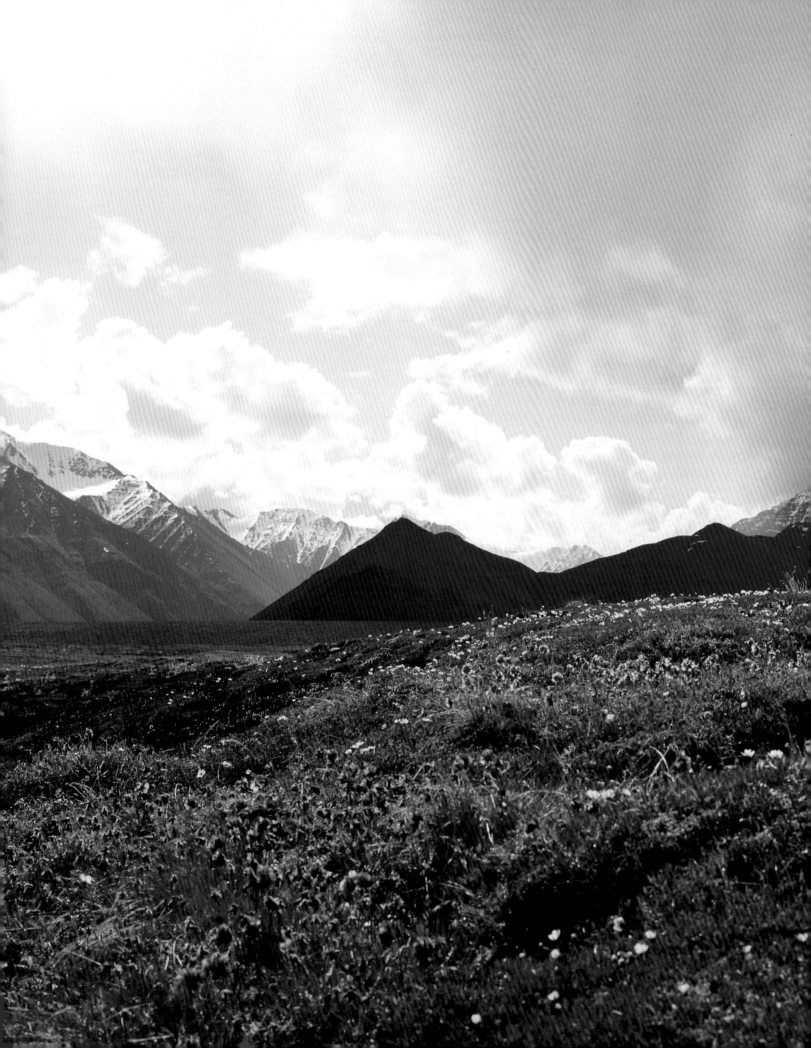

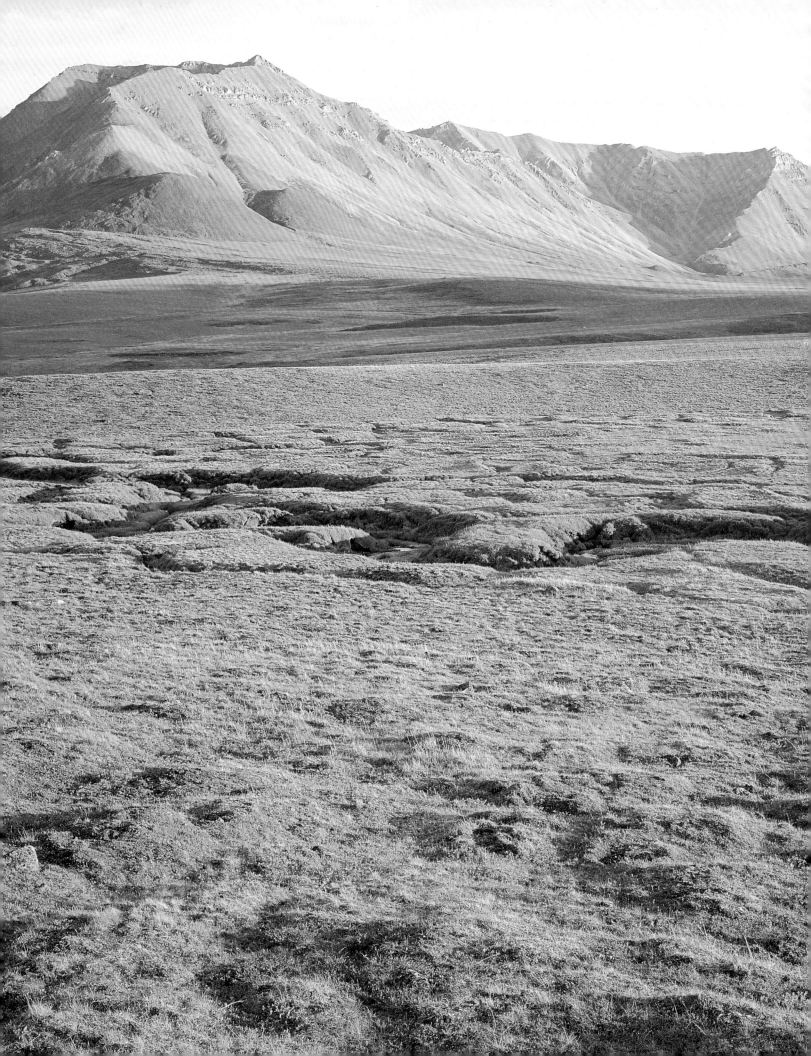

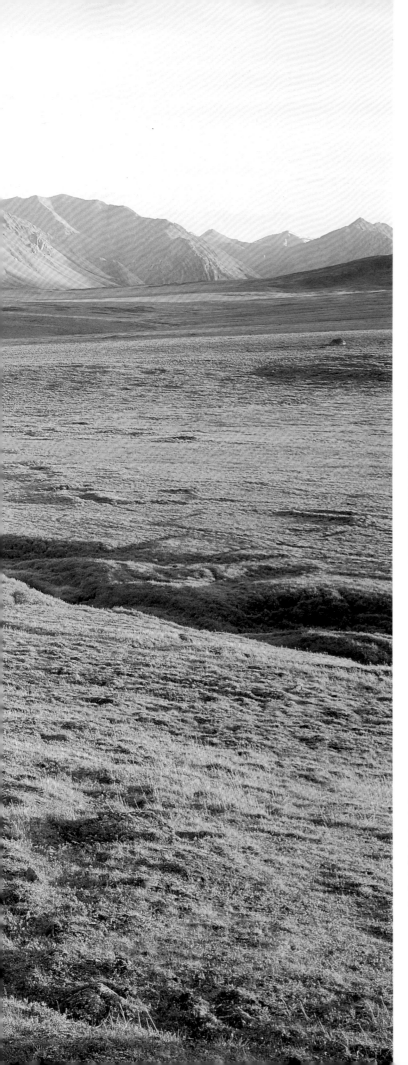

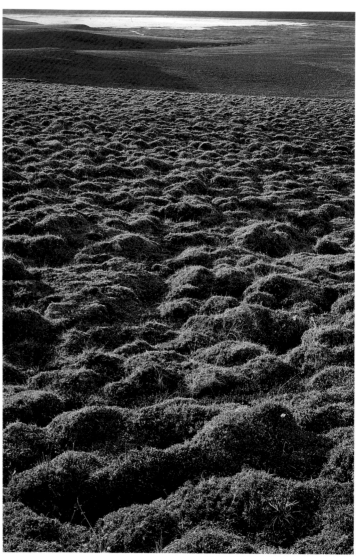

The enormous U-shaped valleys that were carved by glaciers several millennia ago invite the exploration of their distances, like this midnight landscape near the shores of lakes Peters and Schrader, at left. Waiting for the unsuspecting hiker, however, are cottongrass tussocks, like those shown above, which make walking a test of balance, dexterity, fitness, and determination.

them. The tussocks, I remark, look like Hobbits buried up
to the neck. It is an amusing image to think about, less
amusing to negotiate. After half a mile of this, the ground
begins to rise a little to meet each step, the tussocks drop
behind us, and we are climbing. With each passing yard
the angle of the climb increases, the pull on the leg mus-
cles grows more demanding; it becomes easier for me to
forget where we have been and to begin to think only of
where we must go. Soon, the climb also becomes more
interesting: high above us, on a little bench between some
rocky outcroppings, we see a small band of Dall sheep
grazing. From this distance, they look like tiny white
grubs against the greening-up slopes and dark stony
ledges. If they have detected us by sight, sound, or smell,
they give no sign, so we continue to climb toward them,
as silently as possible. We are perhaps fifty yards away
when we flop on our bellies at the lip of an outcrop to
watch, cameras out and clicking. They give us a few min-
ues of their time, then, with a casualness that borders on
contempt, they move up the mountainside by a path invis-
ible to us, until they disappear, one by one, over the
highest ridgeline.

I never do make it to the top; the best I can do is a high
saddle between our mountain and the next one in the line
of peaks. But it is enough, it is enough. I sit on a rock,
stuffing trail mix into my mouth, and look down the
mountain to where we have started. It seems an impossi-
bly long way we have come. The bright tents on the
gravel bar by the river are pricks of color, our compan-
ions too small to see. And spread before me, like some
enormous diorama, is the sweep of the valley with the
jumbled curtain of the Romanzof Mountains rising be-
hind it. To my right, looking toward the south, I can see
the line of peaks that marks the Continental Divide, and
just under those the shimmering trickle of Itkillik Creek
as it wanders down to join the Hulahula at the wide bend
out from the canyon where the river keeps its headwaters.
To my left, looking north, I can see in the farthest dis-
tance what may be the dim blue notch in the mountains
that would mark the point at which the river flows out to
the Coastal Plain and from there to the Beaufort Sea. If it
is, then between those two vantages I am looking at more
than twenty-five miles of wide valley with the Hulahula
braided through it like a great, silver gray rope. This is *big*
country, I say to myself, not for the last time.

By the time we have rounded our moutain and struggled
downslope and back across another tussock field to camp
and dinner, the wind is up and clouds have moved in with
intent. Up on the mountain we were warm enough to

*From the higher slopes of the Brooks Range, it is still possible to gaze
out over the glorious jumble of mountains and perceive the same
"winter-buried mystery of the Arctic" that explorer Robert Marshall
saw more than fifty years ago.*

32

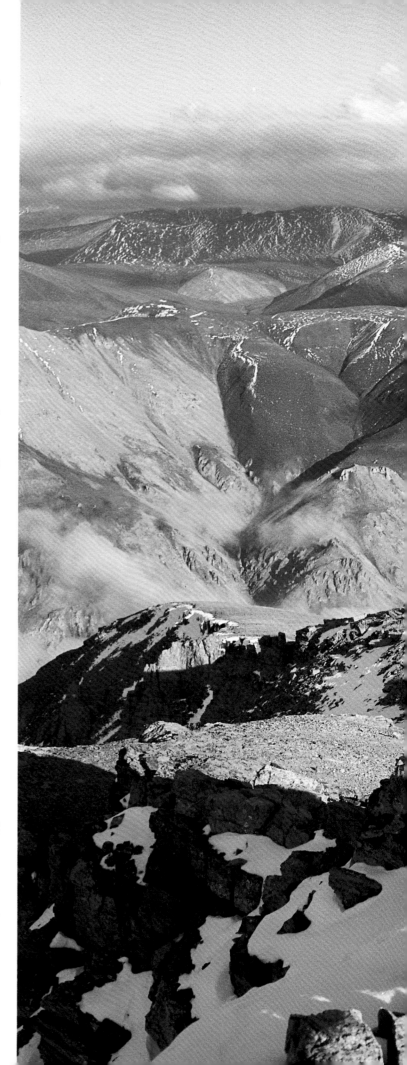

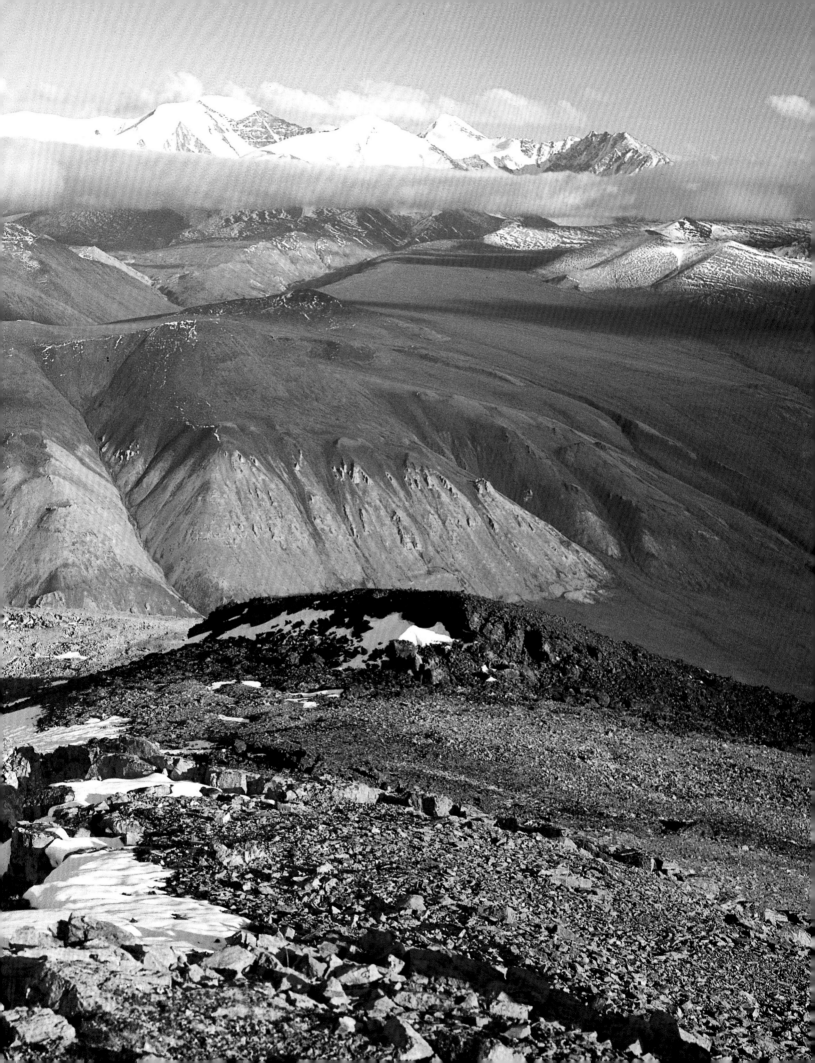

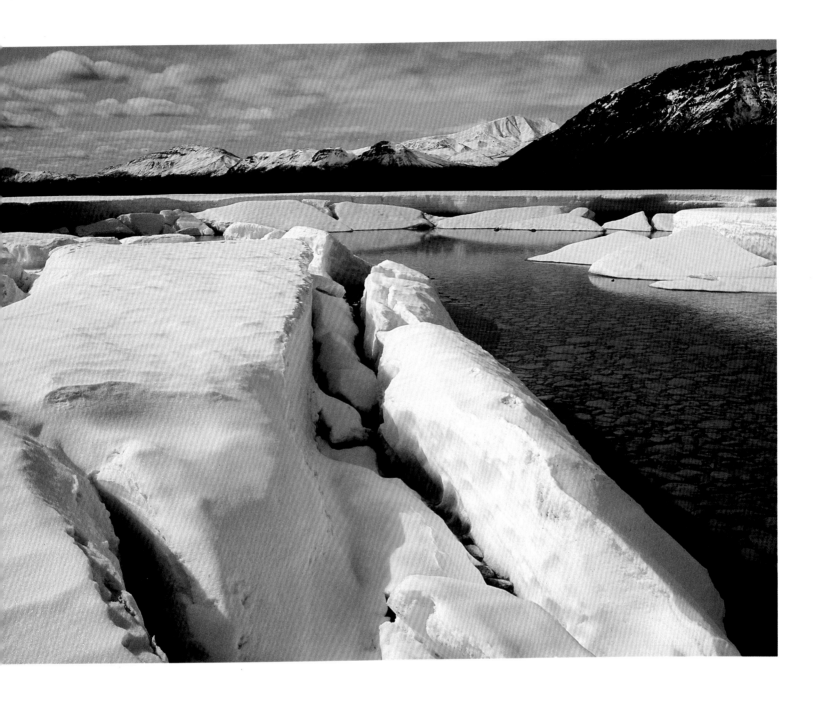

strip clothing from our backs; now we are cold. A long twilight settles down on us like a cloak as we huddle in the cook tent, then bundle into our sleeping bags in the everlasting gray day. In the morning (we call it morning, our watches say it is morning, but who can tell?), both the clouds and the wind are still with us as we prepare to take to the river in our three big rubber Avon rafts. We are given paddling lessons by the trip's leader, Jim Campbell, and by our boatmen, the MacKenzie Brothers. They are not *the* MacKenzie Brothers, of course. I have taken to calling them the MacKenzie Brothers because they share a rambunctious spirit that reminds me of the fey Canadian comedy team. They are the Udall cousins—James (Randy) Udall, a writer, son of Congressman Morris Udall, and Tom Udall, a lawyer, son of former Interior

Above, aufeis *on the upper Sheenjek River. On the opposite page, a brave kayaker plunges through some of the same rapids on the Hulahula that challenged the author and his friends.*

Secretary Stewart Udall. Patiently, emphasizing the dead seriousness of what they are saying now, Campbell and the Udalls put us inexperienced members of the party through our paces: how to hold the paddles, how to use them, and when.

Then we are on the river, three boats of us, a motley crew wearing a variety of presumably waterproof outfits beneath our bright red life jackets: Campbell, co-owner and operator of Arctic Treks, Inc.; the Udall cousins; Susi Alexander and Karen Jettmar of The Wilderness Society's Anchorage office; Peter Coppelman and myself from The

Wilderness Society's Washington headquarters; Ginny Wood, an old Alaska hand, and one of our guides and boat experts; Sam Meek, an adventuresome broker from Florida, and George Mobley, a writer and photographer, and his wife Marilyn.

The life-jackets seem unnecessary this first day. The river is low and gentle, giving us a riffle or two to trifle with, but nothing that threatens navigation. The rest of the clothing does not seem superfluous—if anything, it is not quite enough. It is gray and bone-cold on the river; clouds gather across the top of the valley until they fill the sky from mountain range to mountain range like a black lid shutting us in. Behind us, all day, we can watch curtains of rain following us down the valley, and by mid-afternoon they catch us and stay with us as we float along on the untroubling current, at one point past a wide expanse of *aufeis* whose appearance only emphasizes the needling cold of the rain. When we finally pull in and set up our second camp, we have floated about sixteen very damp miles.

We eat damp that evening and sleep damp that night, the rain playing drumbeats on our tent tops, the wind clamoring outside the zippered flaps. But at four in the morning the clouds and the rain are gone, and the sun is so brilliant it wakes those of us who have managed to sleep. We crawl out into the penetrating light and spread our clothes and bedding to dry on every dwarf birch and willow we can find. Across the river Mount Michelson has presented itself, nearly nine thousand feet of a sharp-edged massif whose upper slopes are buried in drifts of snow that are impossibly, incandescently white against the cerulean glory of the sky.

We have camped where we are because our first stretch of true rapids lies ahead, and Campbell did not want us to try shooting them at the end of that long and demanding day. It is not much of a stretch—just a few hundred yards of rough water in the mile that lies between where we are and where we will camp again at the mouth of Kolotuk Creek on the eastern side of the Hulahula. Rough water and a lot of it, for yesterday's rain has caused the river to rise a good foot, and the current is moving along now with some speed. Half of us choose to walk over the hills to a pickup point on the far side of the rapids; the other half will go with the rafts through the whitewater. I am one of those who get to go with the rafts.

It is over too soon. As we round a curve and slip into the head of the rapid and begin slithering and bounding over and around the boulders of what experienced river-runners call a "rock garden," I know in my mind that this is not a very dangerous rapid (I have seen photographs of far worse), but it is my first, and in my heart I'm crying "Class V! Class VI!" while Tom Udall is, in fact, yelling "Forward! Back-paddle! Harder, harder!" As we scoot past the last rocks and slide through the tongue of the

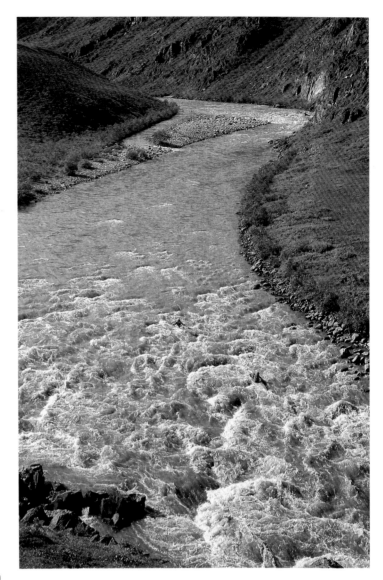

rapid, drenched but safe, I can feel a smile implanted like something artificial on my face.

We camp for the rest of this day and all of the next on a grassy flat where the Kolotuk meets the Hulahula. There is more hiking. After dinner the first night, the Udall cousins march off to climb Mount Michelson (their rambunctious spirit again), coming back the next morning numb with happy exhaustion. Others go up the canyon of Kolotuk Creek as far as they can. I am not so ambitious, myself, choosing to wander around the lower slopes of the mountains, spending a leisurely day photographing lichens and flowers when the wind will let me. At one point, I find myself a thousand feet above the valley floor. Below me an unusually wide stretch of river flows in a graceful curve through a field of *aufeis* perhaps a mile across. Like the sound of distant artillery fire, I can hear the thunder as undercut shelves of ice break off into the river. That, I know, is where we will be the next day.

That day is June 21, summer solstice, a special day in

this land of little sun, the longest and brightest in the arctic year. To celebrate we don commemorative T-shirts that Susi has had printed up and has smuggled along on the trip. "Hulahula River, Summer Solstice, 1987" they read on the back; on the front "Arctic Alaska" and a nice picture of a caribou. With these we put on toy sunglasses, Karen's contribution, to satirize Interior Secretary Donald Hodel's prescription of sunglasses and lotion to keep out ultraviolet rays when the ozone layer is finally done in by fluorocarbons. It is a moment worth preserving, so Karen and I set up our tripods, put our cameras on automatic, and run to join the others before the shutters are released. And there we are, emulsified forever. By now, we all look not only motley but bedraggled.

We are more bedraggled by the end of the day, for it is one that validates my deranged grin (which at times becomes something closer to a rictus of fear). The day begins sedately enough, a run through a few rapids that are mild by comparison to our first, then a slow, otherworldly float through the *aufeis*, whose layered bands of ancient ice rise ten, fifteen, twenty feet above our rafts, glimmering in shades of green and blue, tiny waterfalls of meltwater flowing in thin rainbowed sheets over their lips. Every now and then a huge piece cracks off with a thundering clap of sound. One of these almost swamps a raft that has drifted too close. It escapes, and we all laugh in relief. Then we are suddenly too busy to laugh. The river narrows between the walls of ice, is all at once toothed with boulders and muscled with the shoulders of whitewater. I lose sight of the other rafts and soon have thought for none but the one I'm in. We are tossed into

whorls, spun, roller-coastered, waves of water so cold—it stops our hearts—slam into us and over us, a loose berg of broken ice comes up from nowhere and almost capsizes us, the water traps us against a rock with inconceivable hydraulic pressure, tips the raft up, up, shows us for a moment the face of real danger, then rips us free and carries us leaping from one boiling crest to another. Behind me, over the roar of the water, I think I hear the sound of Tom Udall's voice screaming instructions and I can only hope I'm doing something that approximates whatever it is he wants me to do.

Then we are out of it, spit out into a stretch of water that moves swiftly but seems placid as a lake after the turbulence through which we've just passed. It probably has taken us no more than three or four minutes to get through the nasty patch, but it seems to me that I once flew across the country in less time. Behind us, the other two rafts are disgorged into the quiet water, and, laughing outrageously, the adrenaline still pumping through our bodies, we head downriver. There will be other rapids before this day is over, some of them every bit as challenging as this one, but none will register in my memory with quite the same clarity as my first taste of river-running as it is (and as it should be, I say later with the solid assurance of a veteran in such matters).

For much of this day, the river valley has been getting steadily narrower, till toward the end we are moving through what can only be called a series of small canyons, where the walls are no more than two hundred yards apart at times (hence the repeated stretches of whitewater). After the last of these, both the valley and the river begin to broaden once again, and to take on a gentler, more sedate character. We are beginning to leave the mountains now, and I know it will not be long before we have reached the Coastal Plain and the last leg of our journey. Before then we will make one more camp, but before that I am given a jarring reminder that even in this unquestioned wilderness, the purest piece of wild country I have ever experienced in my entire life, the human presence has left its mark. Twice during the last of this day's traveling I have noticed clusters of rusty oil drums left on low river bluffs several miles apart. These, I am told, are caches for Fishing Hole No. 1 and Fishing Hole No. 2, sites on the river where in the winter the people come to fish through the ice. Alaska Natives: the Inupiat; those we call Eskimos. And, I remind myself, if the junk they have chosen to leave behind is offensive to the eye in this place of wild and empty beauty, if it reveals with a certain stark precision the contrast between the earth untouched and the earth defiled—well, then, for that very reason it is symbolically convenient.

Delicacy and power: at left, clumps of wildflowers decorate the banks of a rushing creek; at right, the Canning River curves through foothill canyons it has carved.

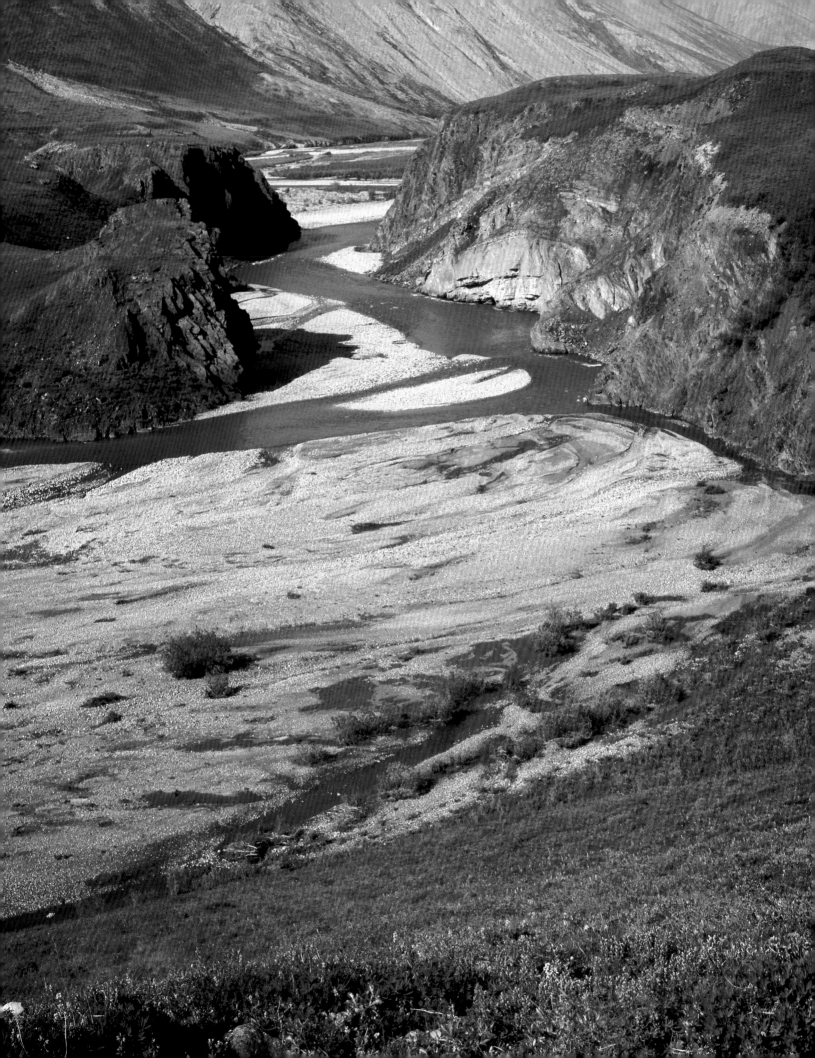

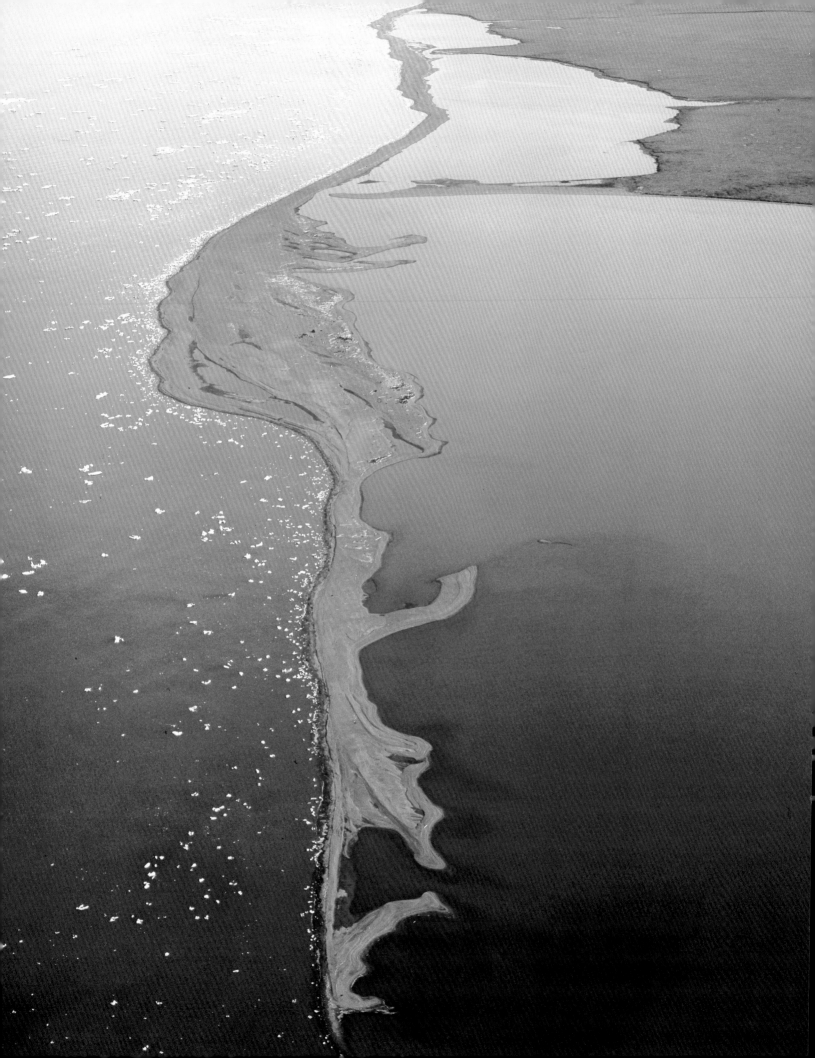

The People

Humankind's relationship with the area of Alaska that would come to include Arctic Refuge has been a kind of long wandering—by paleolithic peoples who came over the ancient land bridge from the Asian continent in two waves, first about twenty-five thousand years ago, and again about thirteen thousand years ago; by English navigators in search of a dream called the Northwest Passage in the late eighteenth and early nineteenth centuries; not long thereafter by a mix of Europeans and Americans in search of whales and seals and other things to kill and sell; more recently by archeologists, anthropologists, biologists, and geologists in search of nothing less than knowledge, and by a handful of folk in search of nothing more than the place itself and the beauty contained within it; finally, by those in search of something else contained within it, something they could suck up and sell: call it energy.

First, the original people. Most of them spilled across the land bridge and flowed southward, multiplying, spreading throughout the North American continent and on into Central and South America, a migration that consumed uncounted thousands of years and produced all the bewildering varieties of native peoples who were on hand to receive and be all but crushed by the full weight of European culture and avarice that was carried across the sea in the sixteenth century. But northern Alaska was populated by a kind of backwash from the great migration, bands of people who wandered more eastward than southward, some of them moving north by northeast through the North Slope of the Brooks Range, all the way to Demarcation Point and points even farther east, through Canada and as far as Greenland. While they divided up into two classes of people—the Tareumiut, who

lived on the coast and the Nunamiut, who lived inland—these early Alaska Natives shared a common language throughout their territory; it would be come to be known as Inuktitut. Refined by centuries of use and ornamented by various local idioms, this is the language spoken among the Eskimos today; those of the Coastal Plain call it Inupiaq.

They were—and remained until very recent times—entirely a subsistence people: they fed and clothed them-

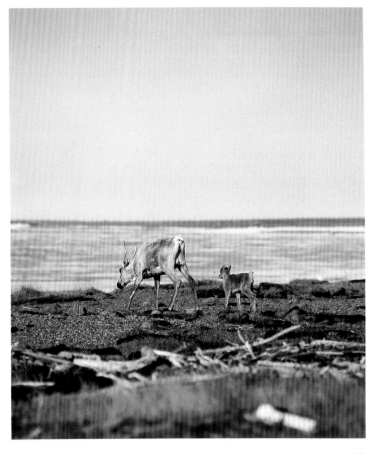

At the continental edge, Barrier Island, left, is strung along the northern coast like a long wall, while on the shores of Camden Bay, right, a caribou mother and calf wander the beaches in search of food and relief from marauding insects.

39

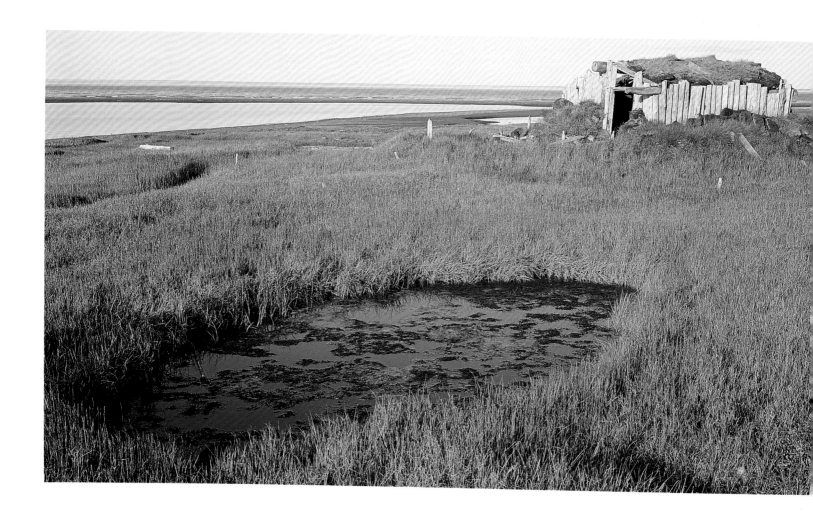

On the Coastal Plain, the marks of nature are—so far—still more frequently seen than those of humankind, though both can be found. At left are caribou tracks; above is an ancient sod-and-driftwood house on the shores of Beaufort Lagoon.

selves on what they could take from the land and the waters. On the coast, it was seals and bowhead whales and fish from the ocean and the mouths of the rivers, as well as wildfowl and the occasional polar bear. In the interior, across the Coastal Plain and into the valleys of the Brooks Range, it was caribou—*tuttu*, they called the beast—and Dall sheep, for the most part, augmented by moose, grayling and arctic char from the rivers, wildfowl, even wolves, wolverines, and grizzlies. Above all, *tuttu*. For the Nunamiut, especially, the caribou was life itself. "Caribou meant everything to them that buffalo meant to the Plains Indian," Kenneth Brower has written in *Earth and the Great Weather: The Brooks Range*. "From the neck, spine, and from the backs of the caribou's legs, the Nunamiut got sinew for sewing. From the bone and antler they fashioned utensils, tools, and weapons; from the hides they made tents, bags, kayaks. The caribou's skin was perfect for winter clothing. It was light, flexible, and good insulation. . . . Caribou skin warmed the Nunamiut outside, and caribou fat warmed them inside."

Neither the Tareumiut nor the Nunamiut ever reached a level of population that could have been described as flourishing—between them, they probably numbered no more than fifteen hundred souls in small coastal villages and nomadic interior bands scattered across tens of thousands of square miles of land. The standard European diseases did their work among these people after the turn of the eighteenth century, and by the middle of the twentieth the remaining coastal populations of the region, reduced now to several hundred, had concentrated at Kotzebue, Point Lay, Wainwright, Barrow, and far to the east, Kaktovik at Barter Island, with another collection of people at Herschel Island off the arctic coast of Canada. The Nunamiut did even worse; by the middle of the 1950s, there were only two tiny bands left, and two decades later, only one band remained residing in the little mountain village of Anaktuvuk. Such is the situation today; Kaktovik, the largest remaining village in the area of the Coastal Plain, numbers only about two hundred Native people.

Across the mountains, over on the South Slope of the Brooks Range, another kind of of Alaska Native settled—Athabascan Indians, whose ancestors had filtered eastward into the somewhat less frigid foothill valleys of the Yukon's northern tributaries. They did not share a language with the Eskimo, but they certainly shared *tuttu*;

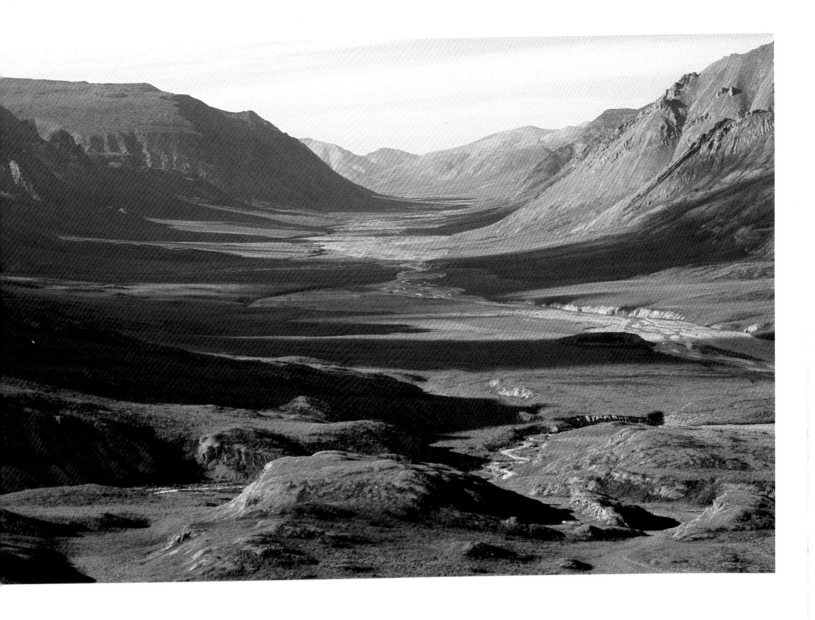

their dependance on the caribou, especially the Porcupine herd during the peak days of its migration to and from the calving grounds of the Coastal Plain, was (and remains) quite as profound as that of the Nunamiut. There were, perhaps, three thousand Athabascans strung through these river valleys at the height of the culture. But they, too, suffered the contact of European civilization and today there are only a few hundred left in such places as Arctic Village on the East Fork of the Chandalar River or Venetie on the Chandalar, together with a population in Old Crow, over in Canada.

In both the north and the south, the people attempt to combine ancient subsistence patterns of fishing and hunting with the demands, convenience, and temptations of the modern technological society that threatens to subsume them. Before we condemn this modern world outright, however, we should note that if it has already distorted these ancient cultures with new pressures, and if its frequently uncontrolled instinct to use and use up everything in sight has the potential for incalculable damage

to both the land and the people it has sustained, this new world also has within it the power to preserve both.

That they should have cared much one way or the other would have been a matter of some astonishment to those Europeans who first ventured into this north country. They had too much else on their minds, as Barry Lopez has pointed out in *Arctic Dreams*: ". . . the history of Western Exploration in the New World in every quarter is a confrontation with an image of distant wealth. Gold, furs, timber, whales, the Elysian Fields, the control of trade routes to the Orient—it all had to be verified, acquired, processed, allocated, and defended. . . . The task was wild, extraordinary." Oh, yes, the trade routes to the Orient: ever since Ser Marco Polo's return from his thirteenth-century journey to Cathay, the nations of Europe had trembled with the possibilities of a land unimaginably rich and populous, where goods could be sold to teeming millions of heathen, and treasure carried away. It was this dream that sent Columbus west to encounter and fix in the European mind the New World, and it was this dream

that would cause navigators of numerous origins to fling themselves against the two sides of the North American continent in search of a route through it; it was in the way, you see.

They called the wished-for way through the continent the Northwest Passage, and one of the places where it might be found, many of them reasoned, was at the top of the world. From the east the Russians tried, and failed, but laid hands on Alaska and plucked her of furs. From the west the French and Italians tried, with no success to speak of. The British pushed on, from both ends—Captain Cook up the West coast by ship, finding and naming Cape Lisburne and Icy Cape; Sir Alexander MacKenzie down the river that bears his name to the Beaufort Sea, but no farther. This was in the latter eighteenth century. A generation later, in 1826, Sir John Franklin tried to

The capacious valleys of Arctic Refuge have a sweep and magnificence unmatched anywhere on the continent; at left is the Hulahula River Valley. Below, caribou cross a summer stream not long after the calving time. Overleaf, tens of thousands of caribou stream through Caribou Pass on their way to the calving grounds along the Coastal Plain. The sheer number of them startle the mind and give the North Slope the character of an American Serengeti.

probe west along the Arctic Coast from MacKenzie Bay, but was stopped by fear of the oncoming winter at a point a little west of what would come to be called Prudhoe Bay. Along the way, his longboat passed Barter Island, at that time little more than a trading outpost between the Eskimos of Herschel Island off Canada and those of Point Barrow and vicinity. In his later account of the voyage, Franklin gave it a few words: It was, he said, "...a collection of tents planted on a low island, with many oomiacks, kaiyacks, and dogs around them...." He returned to the MacKenzie River delta, then home to England and on to other things, including a term as Governor of Tasmania. But he returned—or attempted to—in 1845. Once again, he was out to find and track his way through the Northwest Passage, this time starting from Baffin Bay between Greenland and Baffin Island in the Canadian Arctic. His two ships, the *Erebus* and the *Terror*, disappeared into the never-setting sun of July 1845, and the 129 men aboard them were never seen alive again. Others followed, chief among them Roald Amundsen, who in 1905 would be the first to actually make the passage through the Arctic from ocean to ocean, and Vilhjalmur Stefansson, the first explorer to do

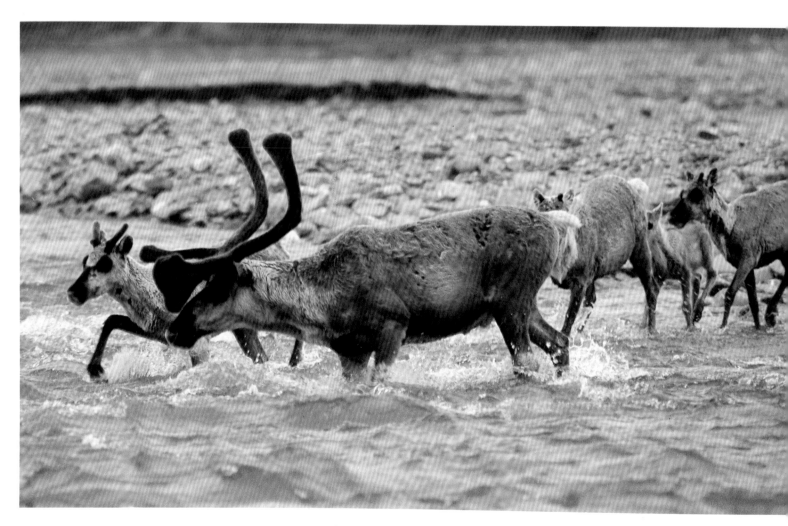

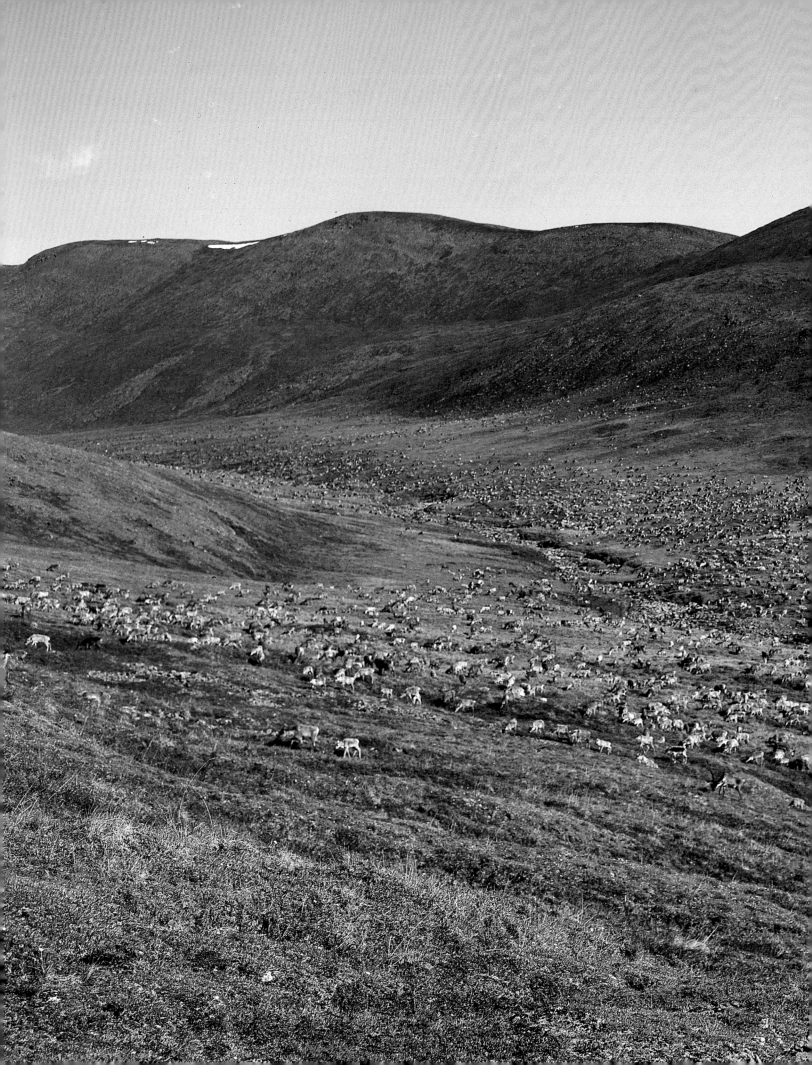

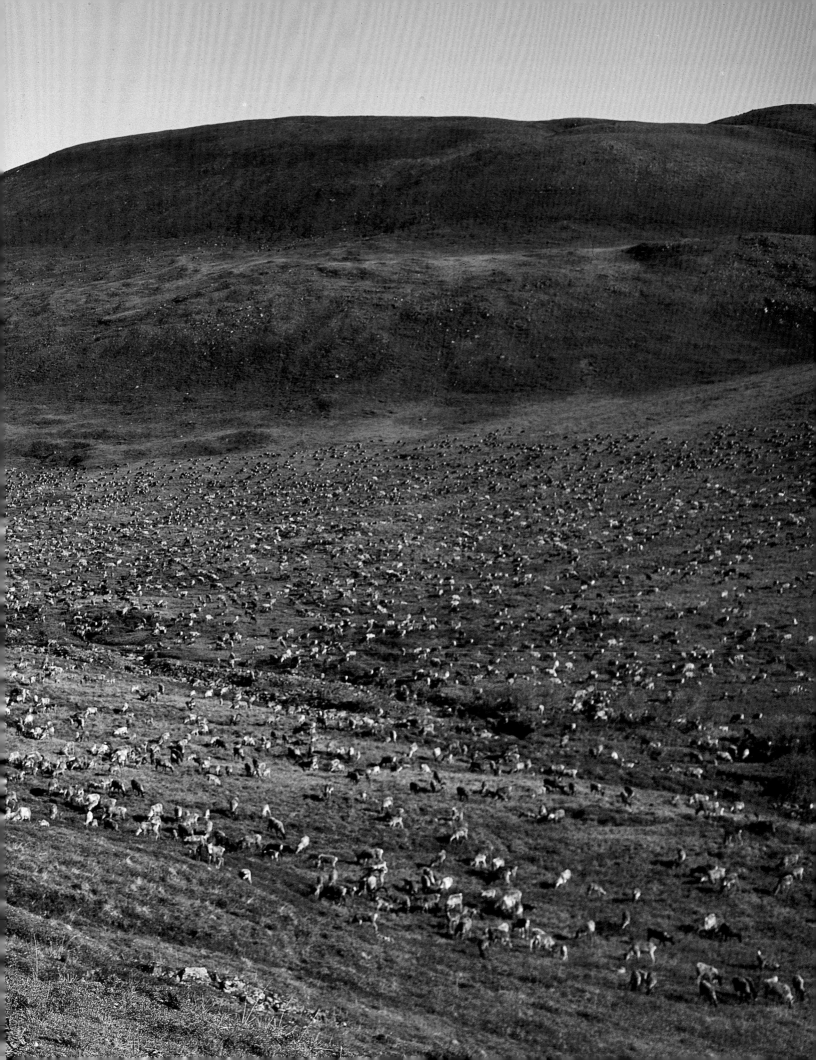

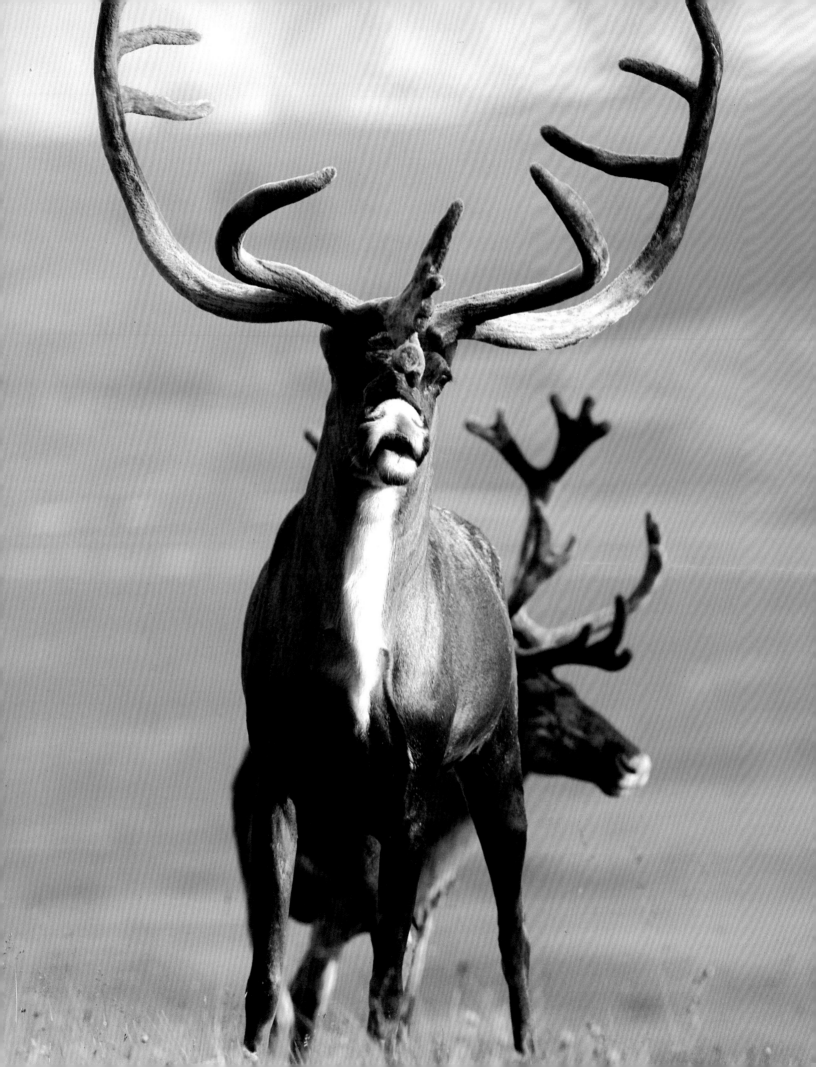

significant discovery work in the Beaufort Sea, this in the second decade of the twentieth century. By then, other kinds of searchers had made passage to the Arctic Coast—made passage, done some killing, and departed after several decades. These newcomers were Yankee whalers who followed the wake of the bowhead up through the Bering Strait all the way to the Beaufort Sea, where in the middle of the nineteenth century they found thousands of the oil-rich sea creatures (another kind of energy) pasturing every year. They took as many as three thousand in a single season for season after season, and by 1910 the bowhead had been hunted to depletion and the whalers no longer came. The Yankees owned Alaska by then, of course, having purchased it from a Russian czar who had found his New World empire to be a generally profitless thing.

A handful of prospectors and fur traders dribbled into the region of what would be the Arctic Refuge in the latter years of the nineteenth century and the first years of the twentieth, but there was precious little gold to be found and furry critters were not abundant enough to make them an item of commerce, and these enterprises, too, faded. Soon there came scientists: first, archeologists and anthropologists who churned out dense, scholarly monographs with titles like *The Caribou Eskimos: Material and Social Life and their Cultural Position* (Kaj Birket-Smith, 1929), *The Material Response of the Polar Eskimo to their Far Arctic Environment* (Walter E. Ekblaw, 1926), and *The Alaskan Whale Cult and Its Affinities* (Margaret Lautis, 1930). Then there were wildlife biologists, people like Madison Grant, Robert F. Scott, and W. A. Elkins, who came to study and write about the bears and birds and other beasts of the tundra. And Olaus J. Murie, who came to the country in and around the Brooks Range in the 1920s for the U.S. Biological Survey (one of the entities that later would be merged to form today's Fish and Wildlife Service). Murie was sent to study caribou and serve as fur warden in the region (though among the sourdoughs north of Fairbanks, rumors spread that he also was there to enforce prohibition; not so, as it turned out, much to their relief). He brought with him his new bride, Margaret (Mardy), who was not only the first woman graduate of the University of Alaska, but in fact that tiny institution's entire senior class for 1924; and together, often by dogsled, they worked their way through the western mountains north of Wiseman on the Koyukuk River during much of 1924 and 1925. The following year found them in the drainage of the Porcupine River, counting geese this time, clear to Old Crow, an Athabascan village in Canada. On both these journeys, the Muries acquired a love for the big

The caribou perceived and defined: the bull at the left, with his finely-muscled body and spectacular rack, was photographed in the region of the Kongakut River.

country that would blossom into action in the years to come.

Not long after the Muries' travels of 1924–1926, another man came into the country from outside, a young forester who had learned to love wild country in the Adirondacks of New York State. His name was Robert Marshall and he came to Wiseman in the spring of 1930, and spent the next year exploring and writing about new land. He never did get as far east as the Muries had, but he did get into the western mountains of the range above the watershed of the Koyukuk and from there looked deep into the Arctic world. "I do not know what may be the supreme exultation of which a person is capable," he wrote in *Alaska Wilderness* (a collection of writings published after his death), "but it came for me that moment I crossed the skyline and gazed over into the winter-buried mystery of the Arctic, where great, barren peaks rose into the deep blue of the northern sky, where valleys, devoid even of willows, lead far into unknown canyons."

Marshall went to work for the U.S. Forest Service, then for the Bureau of Indian Affairs, then back to the Forest Service; along the way, he also founded The Wilderness Society, a group of congenial souls dedicated to the preservation of wild country—including the far wilderness of Alaska, to which Marshall would return whenever he could until his death in 1939.

So did the Muries return—but not until 1956. By then, Olaus, an early member of The Wilderness Society, had become its director (he accepted the position in 1946) and had helped to lead a newly vigorous conservation community in the successful defense of Dinosaur National Monument against the dam-building designs of the U.S. Bureau of Reclamation—a victory historians have called the central event of the modern conservation movement. He also had designs by now on the northeast corner of Alaska. As far back as 1950, Joe Flakne of the Arctic Institute of North America had suggested the creation of a special wildlife preserve in the Brooks Range country, including the Coastal Plain. At about the same time, wrote Donald Dale Jackson in the Fall 1986 issue of *Wilderness* magazine, "George Collins and Lowell Sumner of the National Park Service, working on an official recreational survey of Alaska, were zeroing in on the northeast corner as a potential park. . . . Collins and Sumner focussed on the northeast both because of its magnificent natural features and because much of northwestern Alaska was already set aside as a naval petroleum reserve. In addition, a U.S. Geological Survey official had advised them, ironically, in light of subsequent events, that a conflict with future oil development was less likely east of the Canning River."

By the middle of the decade, the proposal that seemed most likely to be accepted was the creation of a National Wildlife Range under the aegis of the U.S. Fish and Wild-

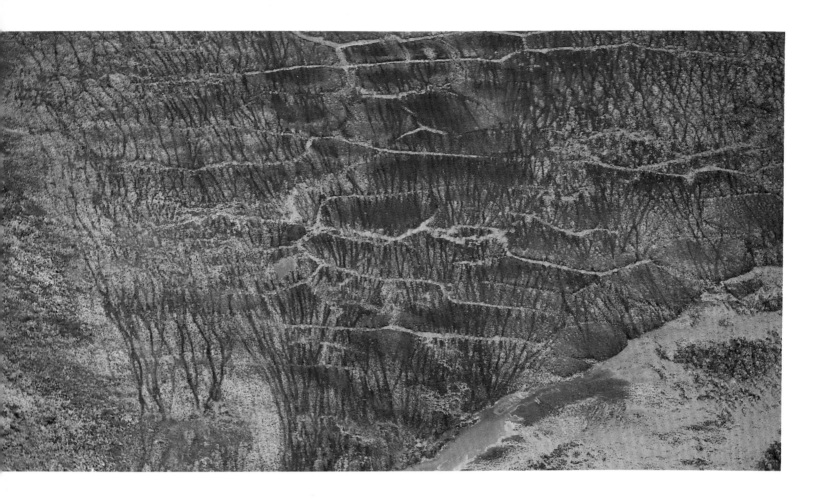

life Service (then called the Bureau of Sport Fisheries and Wildlife), and to take another look for themselves, the Muries encamped at Loon Lake in the watershed of the Sheenjek River, one of the main tributaries of the Porcupine, in the summer of 1956. With them were wildlife biologists George Schaller and Robert Krear, ornithologist Brina Kessel, and—for one week of the summer—Supreme Court Justice William O. Douglas and his wife, Mercedes. They camped and hiked and collected, planning strategy and gathering information and impressions—all to be used in the coming campaign. After their return, the Muries devoted much of their own time and energies as well as those of The Wilderness Society and its minuscule staff to the cause. A bill to establish the range made it through the House but not the Senate, and by 1960, the proposal seemed hopelessly snarled. But on December 6, 1960, Interior Secretary Fred Seaton took matters into his own hands. Mardy Murie remembered the rest in *Two in the Far North:* "On December 7, 1960, I walked out to our Moose [Wyoming] post office for the mail and our postmaster Fran Carmichael said, 'There is a telegram for you.'

"I floated back that half-mile through the woods on a cloud, burst in through the front door. 'Oh, darling, there's wonderful news today!'

"Olaus was at his table at the back of the room, writ-

Over uncounted millenia, the great wandering herds of caribou have left an intricate tracery of paths across the plain, as shown in the aerial photograph above. At right is the valley of the Ikiakpuk River after a June shower. Overleaf, autumn in the Sheenjek Valley, South Slope.

ing. I held out the telegram to him; he read it and stood and took me in his arms and we both wept. The day before . . . Secretary Seaton had by Executive order established the Arctic National Wildlife Range!"

NUMBERS: The Arctic national Wildlife Range totaled about 8.9 million acres. On July 8, 1968, a little less than eight years after the range was established, the Atlantic Richfield Company (ARCO) and the Humble Oil & Refining Company (later to become Exxon) announced that a major strike had been made on the Arctic Coast at a place called Prudhoe Bay, a little over fifty miles west of the border of the range along the Canning River. There were, the oil companies said, at least 9.6 billion barrels of oil beneath the state-owned tundra and permafrost, and they wanted it. The State of Alaska wanted them to have it, too, and on September 10, 1969, it auctioned off 450,000 acres of Prudhoe Bay for $900,220,590. ARCO and Humble Oil then joined with British Petroleum, Ltd. to form the Trans-Alaska Pipeline Systems (TAPS) and filed an application with the Department of the Interior to

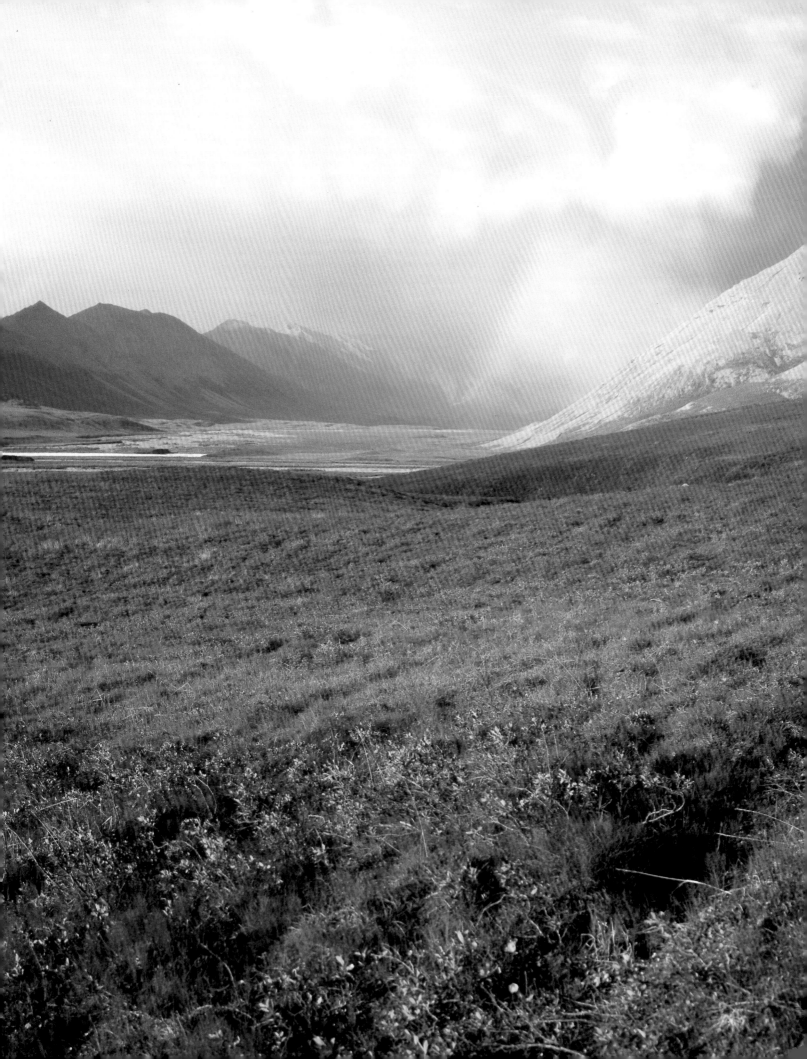

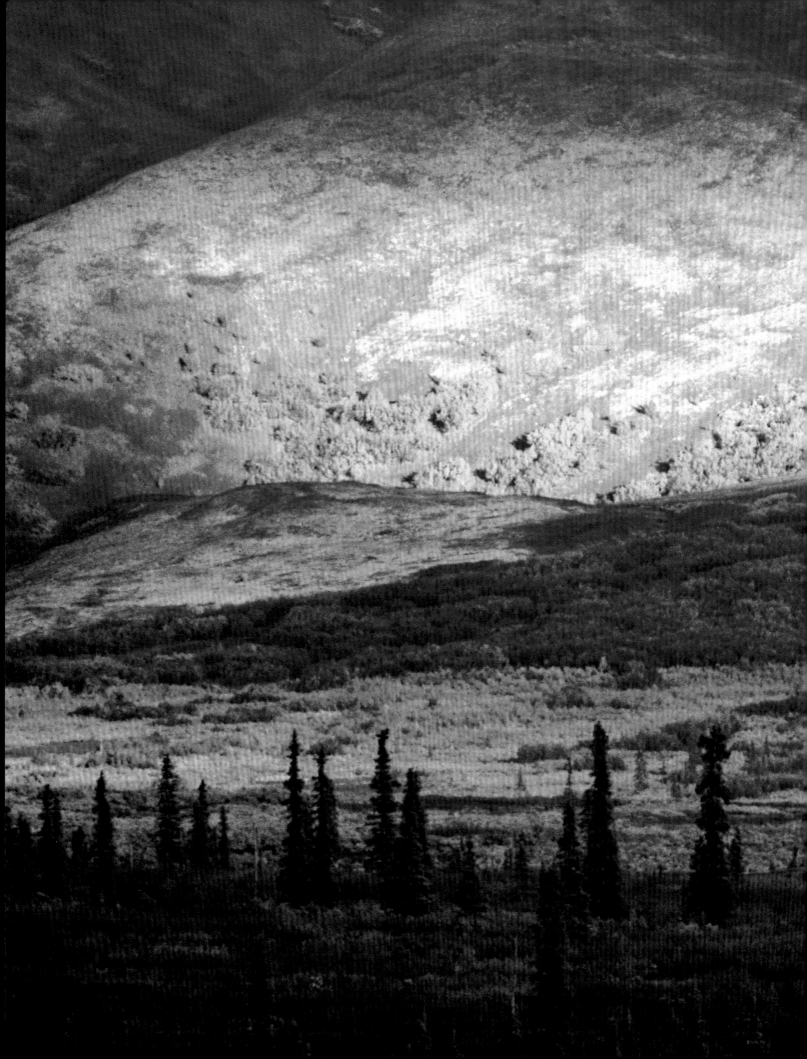

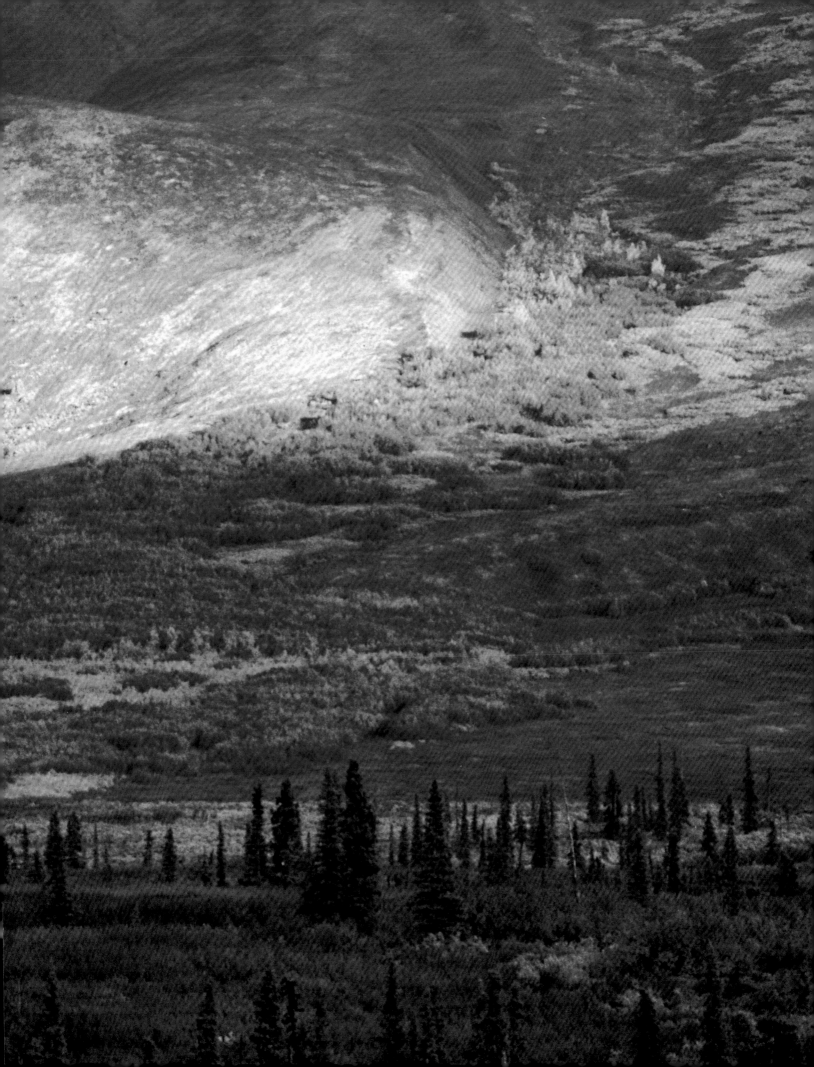

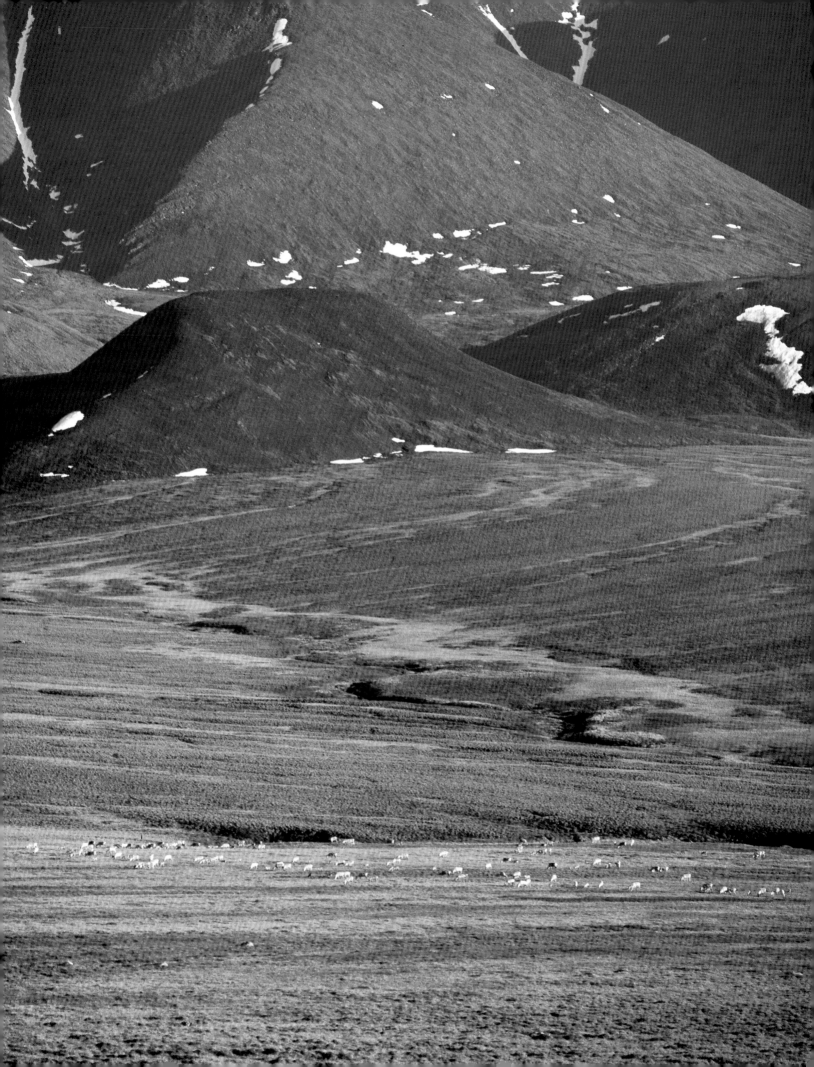

build a hot-oil pipeline eight hundred miles south from Prudhoe Bay through the Brooks Range to Valdez, a little fishing village on Prince William Sound that remained ice-free during the winter. Later, the original three took on five partners, forming a conglomerate called Alyeska Pipeline Service Company, Inc. There followed four years of extraordinary debate. Almost the entire conservation community was dead against the project, and Congressman Morris K. Udall warned that "the oil companies are trying to panic this country and panic this House and this Congress." Conservationists were unable to stop the pipeline in the end, but their opposition did force the companies to come up with a more environmentally acceptable design and to reroute the line in order to avoid a number of particularly sensitive areas. And it was with these stipulations in it that a pipeline authorization bill was passed and signed into law by President Richard M. Nixon on November 16, 1973. By the middle of 1977, the pipeline was completed and the first oil from the Arctic Coast was oozing into the multi-hulled bottoms of tankers in Valdez Harbor.

A little later came another law. After the defeat over the pipeline, the conservation community channeled its efforts toward passage of the most sweeping piece of conservation legislation in American history: The Alaska National Interest Lands Conservation Act (known as ANILCA or, more simply, the Alaska Lands Act). It, too, was passed, signed into law by President Jimmy Carter in December 1980. The Alaska Lands Act established 104.3 million acres of national parks, wildlife refuges, and other conservation units on the federal lands of Alaska, laying over much of this country the additional protective mantle of wilderness designation—no roads, no vehicles, no development of any kind. Among the law's stipulations was the creation of Arctic National Wildlife Refuge, a new entity that incorporated the area of the Wildlife Range of 1960 and added to it another 9 million acres; what was more, the law also designated as wilderness almost the entire 8.9 million acres of the old range.

Good news for the preservation of Arctic refuge? Yes, with one large exception: Section 1002 of the law ("Ten-oh-Two," as it came to be vocalized). This provision set aside 1.5 million acres in a 100-mile stretch of the Coastal Plain for study. This study—to be conducted by various agencies in the Department of the Interior—was to evaluate the area's potential for oil and gas development, to weigh that potential against the impact of development on the land and its wildlife, and to present to Congress its findings and recommendations. The 1002 Study Area, as it happened, embraced within it the core calving areas of *tuttu*—the Porcupine Caribou Herd. And this was where the people still found their sustenance, here in the rolling tundra plain. "The Brooks Range all the way to the ocean is our garden," Archie Brower, mayor of Kaktovik, said in 1979. "We feed on that."

During their time on the Coastal Plain, the caribou feed ravenously to store fat for the coming winter. On the opposite page, a herd grazes beneath the towering foothills of the Brooks Range near the Jago River. Above, a frightened calf pretends that it is just another cottongrass tussock.

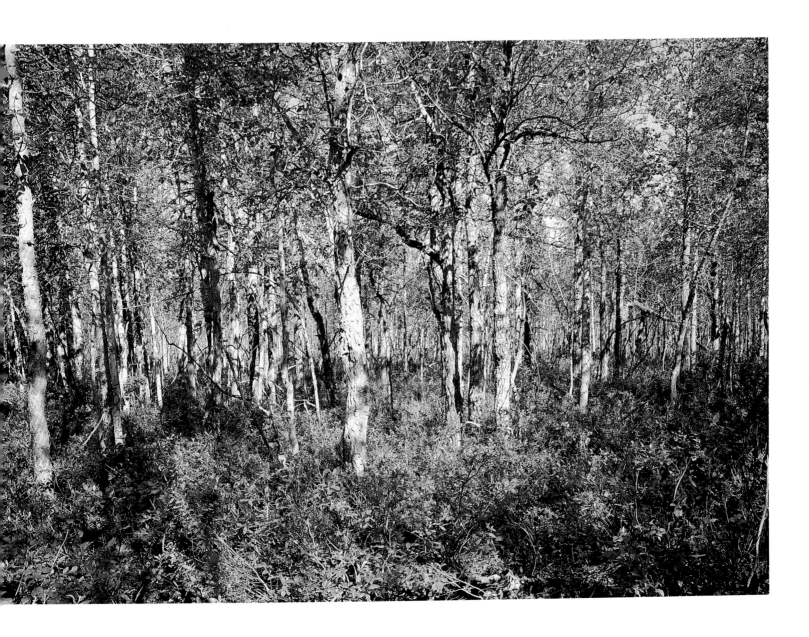

Interlude: In the Lap of Time

We camp again on the eastern bank of the river after all our tossing excitement amid the rock gardens and riffles offered up by the lunging Hulahula. This is a splendid camp, situated on an apron of land at a wide, curving bend of the river. Across the river is a high bluff, and a mile or so beyond that is the gray triangular eminence of Kikiktat Mountain. To the north of us are a series of rolling bluffs that are characteristic of the foothill country of the Brooks Range. Behind just a few of those bluffs, we know, is the beginning of the plain, the garden of the people, the Serengeti of the north. We know already, however, that we will not be seeing the teeming numbers of *tuttu* that are supposed to be there at this time of the year. This is an "aberrant" year (as scientists like to designate those events that refuse to stick to the rules); the caribou have calved early over in Canada, and the migration has started a little late. In the mountains we have seen only distant animals—early arrivals—making a

lonely way by twos and threes through the passes of the mountains.

So we see a little of *tuttu*—but we see a sufficiency of *tuttu*'s greatest natural enemy, the bear. Grizzly. *The* bear. We see him this very night as we set up camp, exhausted from the long day's river-run. At the top of the third bluff to the east he is a dark spot on the land, hundreds of yards away but moving fast, digging enormous divots out of the earth as he goes. As he moves toward us, inexorably, we move toward him, fascinated; for me, it is a kind of hypnosis: this is the largest, wildest, most dangerous animal I have ever seen free in the land, and I can't take my gaze from his rolling, powerful form as he dredges his way across the tundra. A silent knot of

This is country ruled by the imperatives of the grizzly, king critter of the north, who can be found lurking in willow thickets, like that above, near the Canning River, or on the open tundra, where the bear at right was discovered.

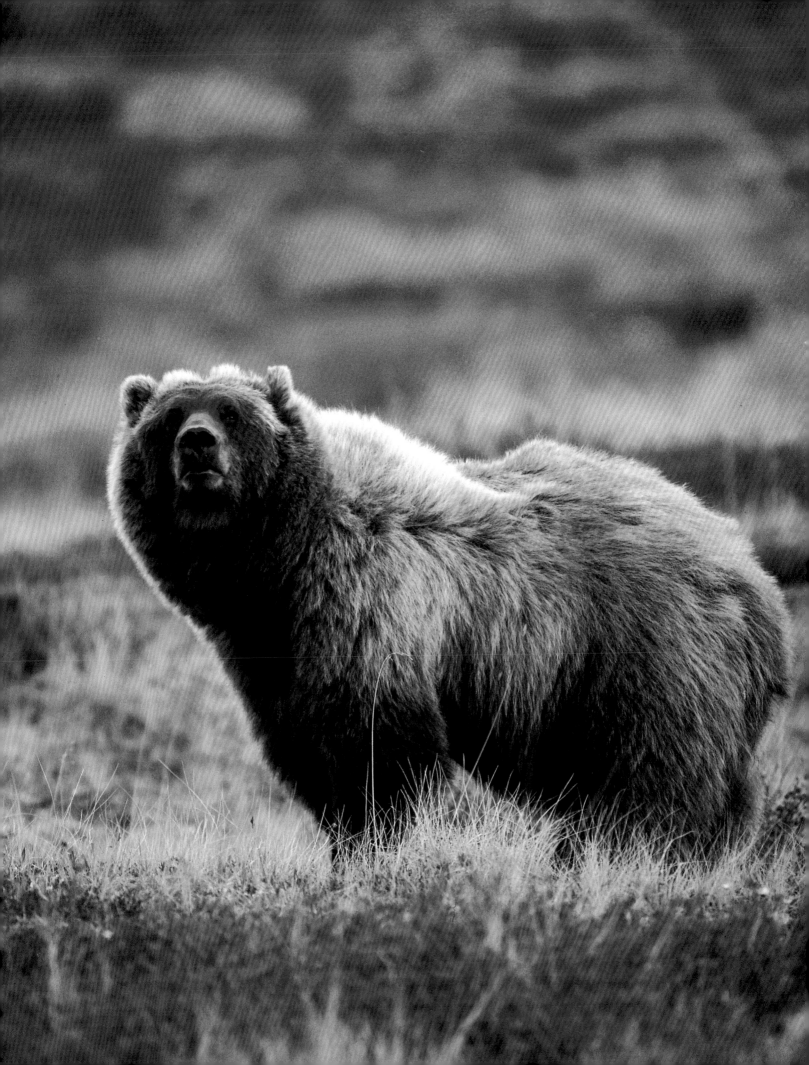

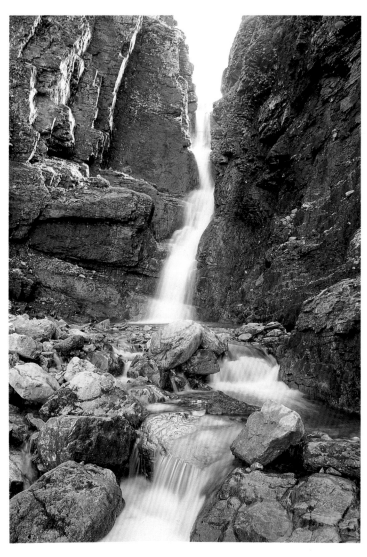

The mountains that rise above the Coastal Plain of the north and the forested valleys of the south, as on the opposite page, are raw and unfinished, still being shaped by the glacier-fed streams that explode from the ancient rock on the way to the sea. The unnamed falls above were photographed near the Canning River, but their counterparts can be found almost anywhere throughout the entire range.

us gathers at the lip of the first bluff, assuming a certain safety in numbers as the grizzly lopes down the last bluff, crashes through the willows along the creek at its base, then moves on to the tussock meadow in front of us. When he is perhaps a hundred and fifty yards away, he suddenly veers and cuts across the meadow at a diagonal, scooping and snuffling with what appears to be some irritation. The wind is against us, however, and his eyesight, like that of all bears, is not very good; the chances are he does not see us, his mind firmly fixed on the possibility of ground squirrel for dinner. Indeed, he does not seem even to glance in our direction as he crosses the meadow and finally disapears into a willow thicket. We can hear him muttering and thrashing about in there for some time before there is a silence that we half hope and half regret means that he has departed our vicinity.

Then another. Not half an hour after the first bear has vanished into the willow thicket, another one appears in the distance, this one at the point of a talus slope at the foot of the mountains to the southeast of our camp. Again, we see him as a black dot growing larger, moving down the slope, out to the tundra, then over the crest of a bluff and on to the edge of the flat on which we are camped. He is a good half mile away, though, and comes no closer, ambling into the willows along another creek and never reappearing.

This is pretty heady stuff for me, and I do not talk much about it with the others. I am a Southern California boy by origin, and we did not have bears of any size anywhere near where I grew up, certainly none so close that they would have come to call just before dinner. I feel again that honed edge of wildness that I experienced four days before on our first hike into the land. Then, merely some torn earth had called it up; now it was the creature itself, and there is a vibration in the air, a sense of something important having passed through. It is not a smell, but it is very like a smell.

The bears are still much on my mind the next morning when I decide to try to get high enough on the mountains to see out to the plain itself. My goal is an outcrop jutting from the brow of a peak maybe four miles away; it looks like a good place for lunch and perhaps the long view north. I fill my water bottle, slip a bag of trail mix into my jacket, hang camera equipment from my body, and under the bright 6:00 A.M. sun, head for the hills from which the second bear had emerged the night before. I know the chances are good that he has long since moved on, but I remind myself that there are no guarantees in this life.

In the end, I encounter no bear during the next eight hours, but I do see a lot of country, and much that lies within it: the tiny, cold, sweet spring that chuckles out of the muddy tundra at the head of the little creek at whose bottom the second bear disappeared; a 750-foot talus slope made of large, broken pieces of shale, scattered like

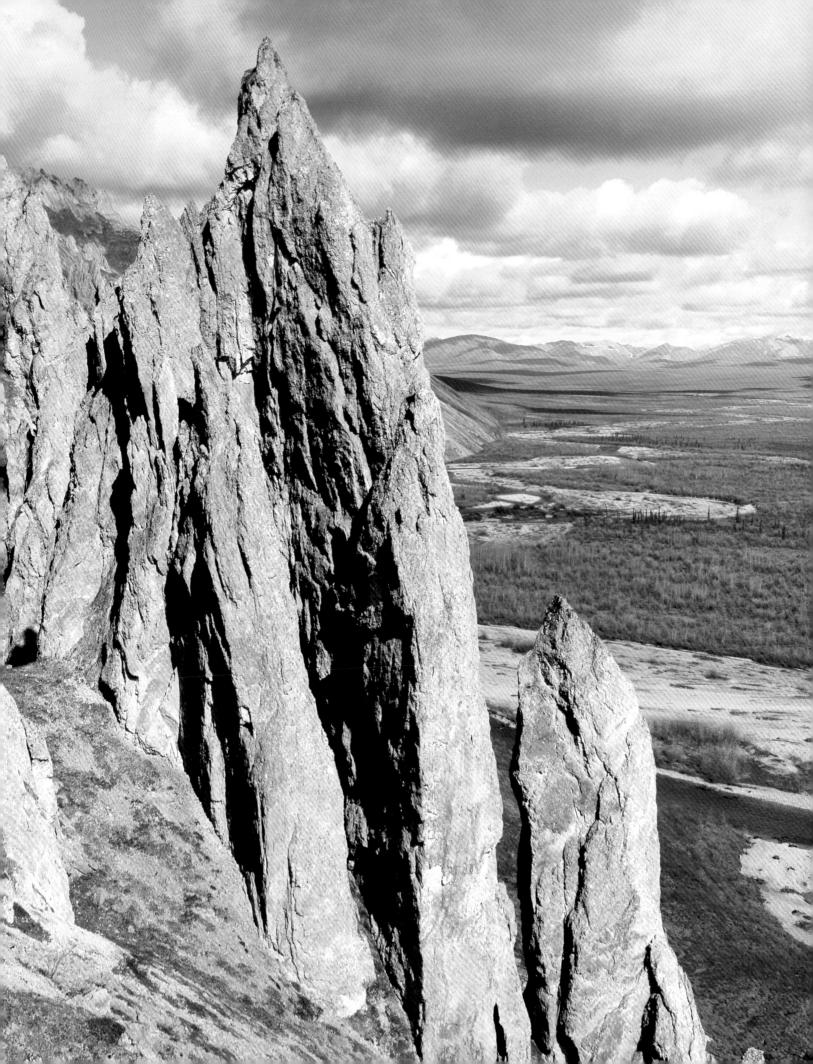

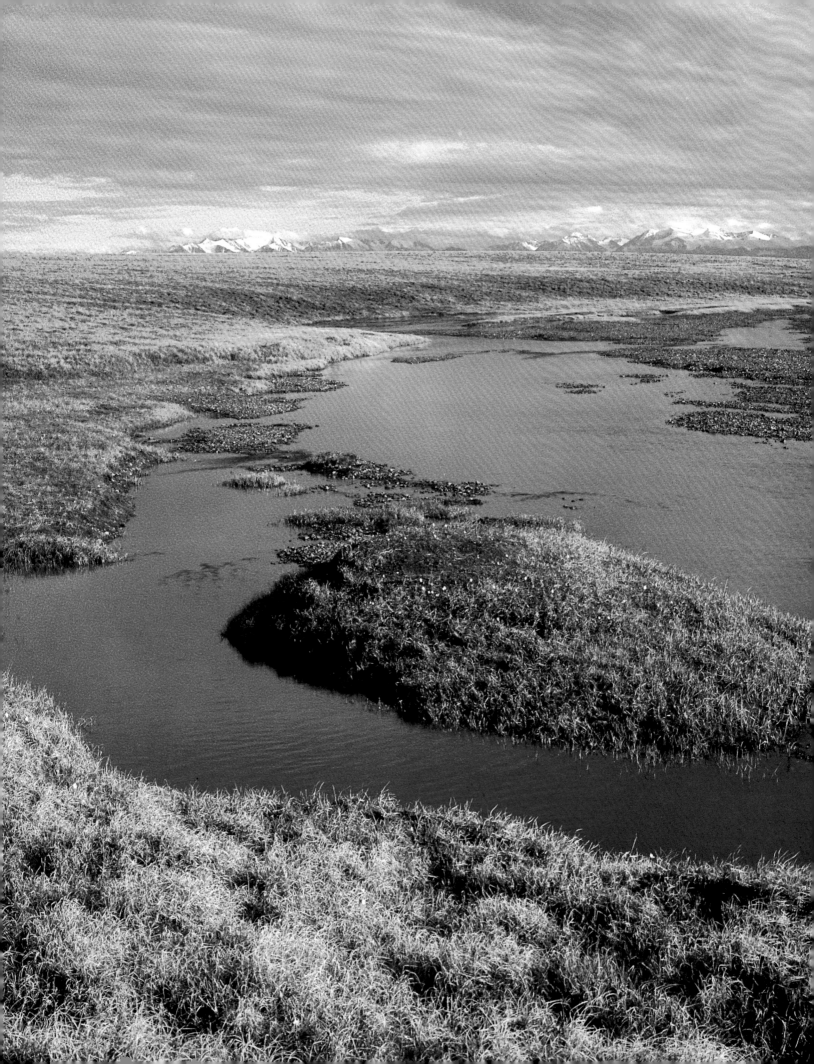

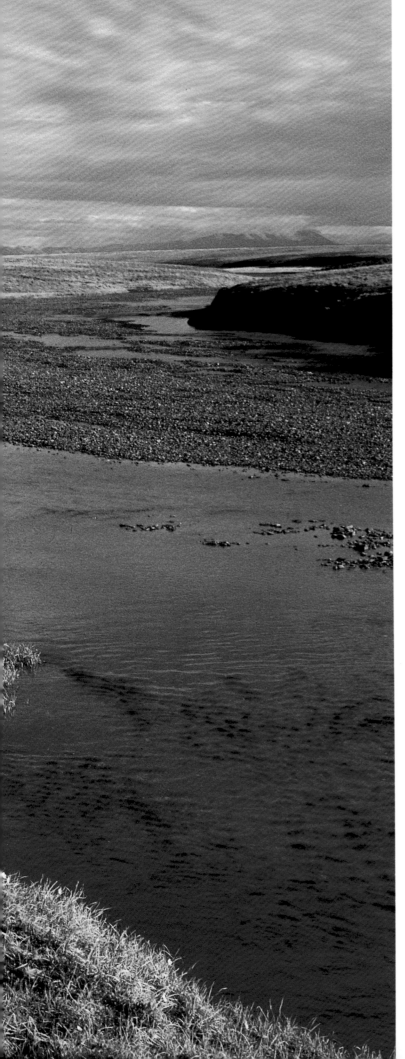

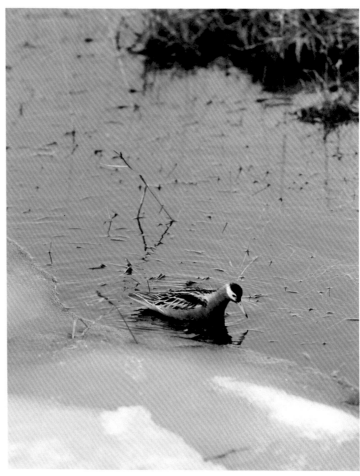

It is one of the functions of permafrost to make of the
Coastal Plain one of the great wetland resources on
the North American continent. Surface waters, prevented
from seeping deeper into the earth by the impermeable
layer of permafrost, wander across the plain in wide,
braided rivers or collect in shallow tundra ponds.
At left is an unnamed stream near the
Okpilak River; above, a red phalarope floats on a
pond south of Camden Bay.

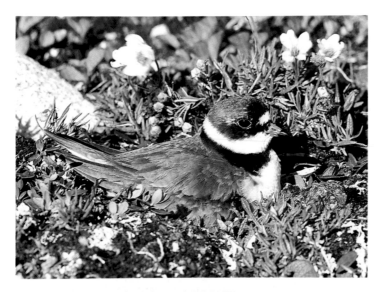

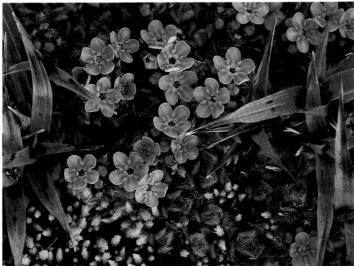

Parts of a magnificent whole: directly above, a semi-palmated plover sits on its nest and forget-me-nots wink in the everlasting sun; both were photographed near the Jago, one of the Coastal Plain's integral rivers. On the opposite page is the plain itself, the lap of time.

huge maroon-colored dice down the mountainside, a chancy thing to descend, but I force myself to do it; a wink of water at the far bottom of another, gravelly, slope, down which I butt-slide because at its bottom I think I will see a waterfall, and I do—not one waterfall but three, hidden cascades that leap like shouts of laughter from the rocky heart of the mountains; and finally the plain, seen from my hard-worn seat on the outcrop toward which I have been climbing for five hours.

It is a misty, wondrous sight from this distance. It is what it must be like to see the long horizon of the earth itself from one of the lower satellites careening just above the troposphere. Below me is the high, steep incline up which I have labored; below that are the foothills, and beyond these are the first rounded bluffs that slowly layer out to the plain, an immensity brushed with desert colors, trembling slightly in the heat of the midday sun, its braided rivers shining faintly in the light and distance. Thirty miles away, what appears to be a long thin wafer of clouds fringes the horizon; but it could also be, I assure myself, the pack ice of the Beaufort Sea. I like that idea better, and sitting there, hearing nothing but the mutter of wind over the tundra below me, I entertain a complicated metaphor: if you looked at the Brooks Range in cross-section from west to east and squinted your eyes just right, you might discern the shape of a human figure, seated and hunched forward. The figure's back and shoulders would be the gently rising South Slope of the range, the head its highest peaks, the chest and stomach the more steeply pitched North Slope. And the lap would be the Coastal Plain. Whether the metaphor works or not, I tell myself, it is clear to me that this place is all of a piece, mountains, river, plains, the sea, an entity, an entire creature no one of whose parts can be separated from any other without doing violence to the integrity of the whole. I begin to understand more fully now, as I look out upon the thirty miles of wild, empty plain before me, why those who love the refuge will fight so desperately to keep this fragile magnificence uncorrupted.

The next day is our last on the river, almost all of which will be spent paddling through the Coastal Plain. Late in the afternoon of the previous day, a bush plane had buzzed the camp, and by virtue of a note tossed out, followed by a series of hand signals, we established our plan of action: the morning after this last full day, we will be picked up at a point just ahead of the place where the Okpilak River enters the Hulahula, about seven miles short of the sea; this pickup point will be our camp for the night. Campbell estimates it will take no more than seven hours of floating to make it to the pickup point, and with that comforting thought we take to the river.

What no one could know was that a forty-mile-an-hour wind would strike us when we came through the last

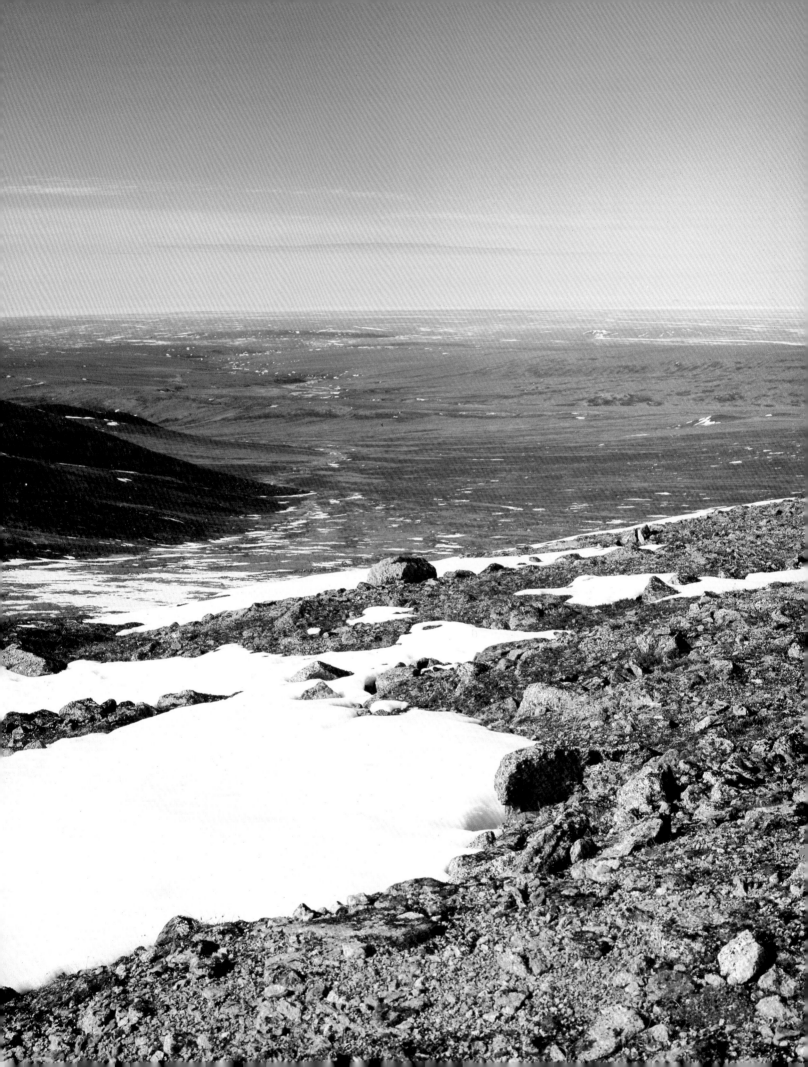

patch of *aufeis* in the foothills and entered the plain itself. This wind is not only strong but cold, coming in off the pack ice like the preliminary breath of winter. The river itself is not as high now, and in these lowlands it begins to wander and to braid, as geographers describe the phenomenon, the main channel increasingly difficult to find. More and more frequently we have to get out of the rafts and haul them by sheer muscle over rocky shoals and back into deeper water. And even where the water is deep enough to float us, it is not moving fast enough to compensate for the wind in our faces. We paddle now, steadily, constantly, working our way downriver at a pace that at times seems to move us by inches, not feet, yards, not miles.

Still, we come farther than we might imagine in the first few hours. The mountains loom behind us at first like an enormous blue wave filling the sky; as the day wears on, the wave will decrease in height even as it increases in width, until by noon we can look back on a sweep of the Brooks Range that seems to embrace the horizon from the Bering Sea to the Canadian border. All along the crest, clouds have gathered like foam.

After about five hours of paddling and wading and paddling again, we pull into the bank for a lunch and rest and exploration stop. There is a time now to begin to truly look at the plain, this place of confrontation, this wilderness at risk. I remember that Harold Heinze, once president of ARCO Alaska, described it as "a flat, crummy place. Only for oil would anybody want to go up there." I reflect that Mr. Heinze had all the aesthetic instincts of a modern Babbitt. I see a peneplain before me, land that is in the last stages of the processes that bring it down to as much flatness as the curvature of the earth will allow. It is true that you can see to the rim of the horizon here, but there is plenty of complexity and detail in the land if you

take the time to perceive it—gullies and shoulders and odd little knobs, over it all the everlasting tundra spreading like a cloak. There is birdsong that the wind brings to you in entrancing rags of sound, and the creatures themselves, tiny shadows that the wind appears to fling headlong through the air. A pair of swans float in a pool of water, gulls and arctic terns clamor in the sky, sweeping down in angry, curving attempts to bomb us with their excrement whenever they feel we are a threat to the nests they have hidden in the stones of the river's gravel bars. Everywhere is the punctuation of flowers—dryas and avens, lousewort and lupine. Dwarf birch and willow thickets line the banks of the river. I walk some distance from the others and stand in the country, turning slowly. I have been here before, I realize, only it was in another place—along the Tongue River in Montana, in the middle of another ocean of grass, not tundra but buffalograss and blue grama and bluestem wheatgrass. But the wind spoke the same language there as it does here, and I have the same exhilarating, vaguely unnerving feeling that I am standing somewhere near the center of things. And here, in this reminiscent place, there is the added glory of the mountains.

And something else, something too ancient to be fully grasped, not now, not later. Back along the banks of the river, in the willow thickets, we find snagged to the branches hundreds of tufts of *qiviut*, the downlike guard hair of the musk oxen, a wisp of softness unlike anything else I have ever felt. Then, on the crest of one of the rolling heights under the curtain of mountains, we spot a tiny puff of dust cloud at the bottom of which is a little herd of the animals themselves. Even with binoculars, it is at first difficult to distinguish one animal from another. But they are moving with astonishing speed, and are soon only a few hundred yards from us. We are drawn to them much as we were drawn to the bears two days before, and we scuttle through the inadequate screen of birches and willows to get as close as we safely can before spooking these shy remnants of the ice age. As if accommodating our curiosity, the herd pauses for quite a long time to rest and graze and consider whether it wants to cross the river here.

If I was struck dumb by my first sight of a grizzly bear, I am hardly less stunned by my first encounter with the musk oxen. This longhaired, curly-horned, round-shouldered beast *looks* as if it belonged in a prehistoric landscape, roaming free at a time when men still peered from the mouths of caves, fearing the darkness. That is one landscape where it belongs. This, now, is another. It is in place here, just as the grizzlies and caribou, the willows and tundra and rivers are in place here, just as we are not in place here, will never be, however much we feel the connections and the subtle dark beauty of the life that stands now before us, regarding us not at all.

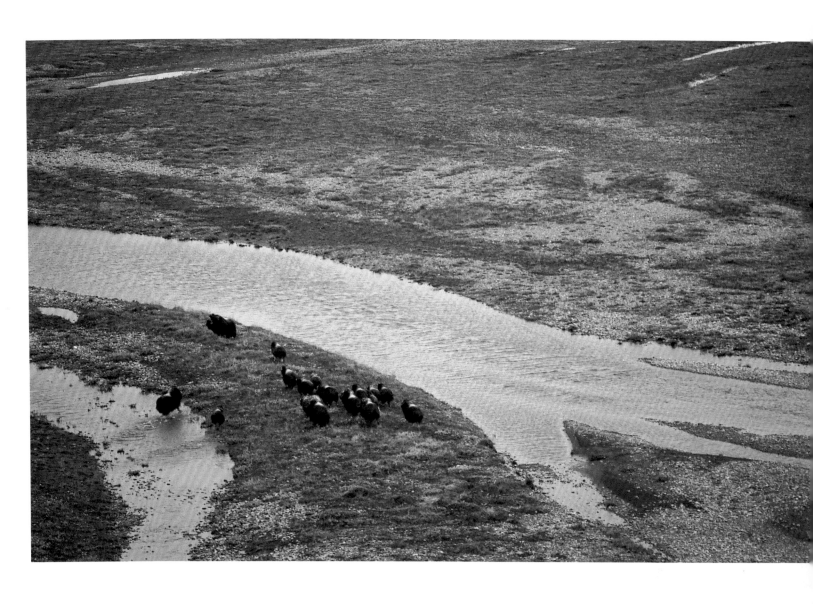

Among the rarest visitors to this peneplain are lesser yellowlegs, a pair of which are seen on the opposite page; musk oxen, however, number about five hundred animals, which roam the Coastal Plain in several individual herds. The herd on this page was photographed along the Sadlerochit River.

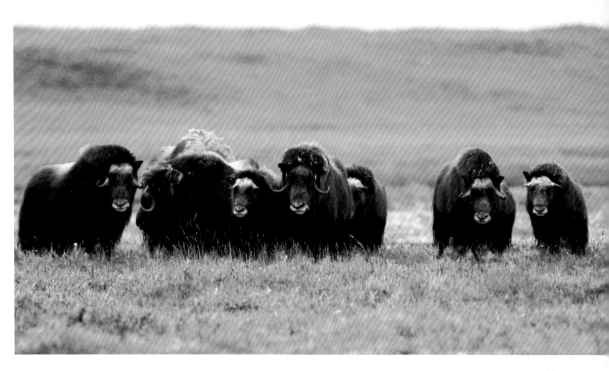

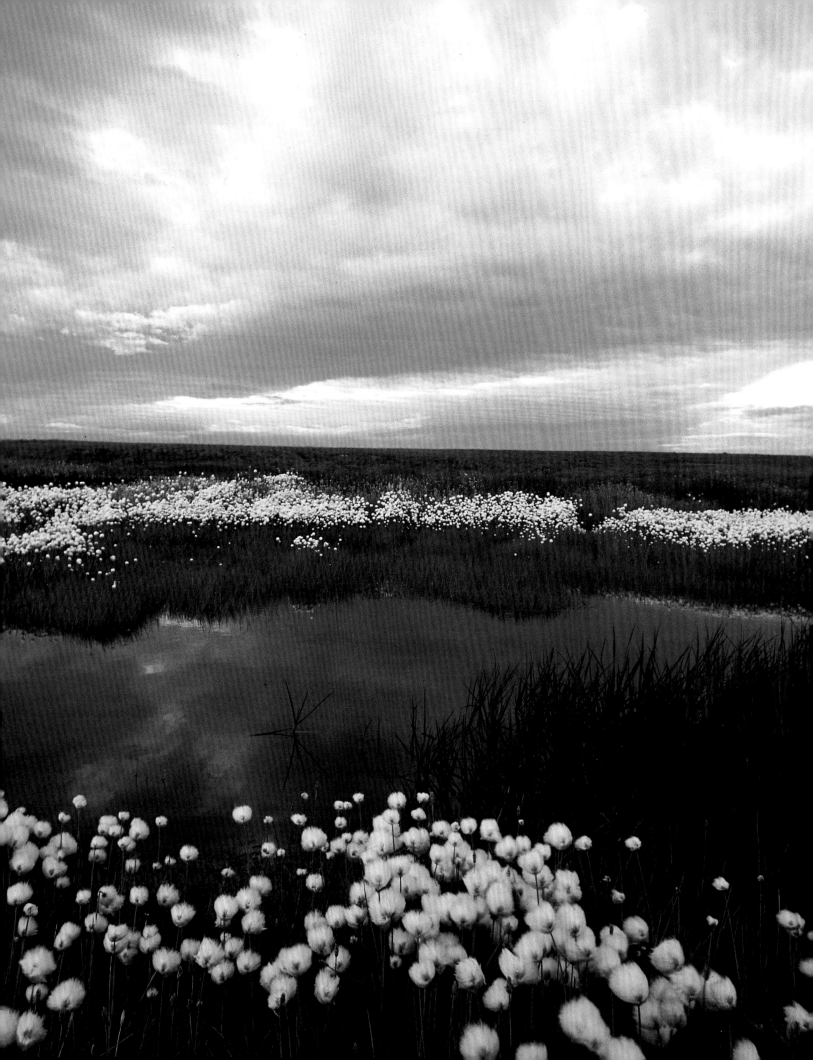

The Problem

Let me offer a fantasy. The coast of California from Oregon to Baja is about 840 miles long. If the proposal were put forth that all but 125 miles of the offshore and onshore areas of that coast be opened to intensive oil and gas development, the uproar, particularly in California, would be of spectacular dimensions. If another notion proposed that even that 125-mile strip of protected coast be thrown open to the drilling rigs of the oil entrepreneurs, there almost certainly would be a petition with ten million signatures calling for the immediate dismissal, recall, or impeachment of the idiot who came up with the idea.

A preposterous whimsy? Of course. And yet . . .

And yet the Arctic Coast of Alaska, from Point Hope on the Lisburne Peninsula east to the Canadian border, is 1,060 miles long—and every single mile of it is open to oil and gas development right now *except* a 125-mile strip of the Coastal Plain, 100 miles of which is called the 1002 Study Area (the rest is designated wilderness), a 1.5 million-acre segment of Arctic National Wildlife Refuge that was placed under study by the Alaska Lands Act of 1980. The total amount of onshore and offshore acreage available on the North Slope of Alaska amounts to 55 million acres of federal and state lands. Onshore, it includes the 23 million acres of the National Petroleum Reserve-Alaska, a federal preserve, and 7 million acres of state-owned lands between the Petroleum Reserve and the border of the Arctic Refuge, where those 450,000 acres at Prudhoe Bay were auctioned off to oil companies in 1969. Offshore, it includes 3 million acres of state-owned tidelands, much of it currently offered for lease—including portions of Camden Bay and the tidelands of Demarcation Point near the Canadian border, both at the edge of Arctic Refuge—and 22 million acres of federal

Outer Continental Shelf lands currently being offered for lease by the U.S. Department of the Interior.

Fifty-five million acres, if entirely on land, would embrace the state of Kansas with enough room left over to jam in most of Connecticut. It is a lot of territory, even by Alaskan standards, and on the face of it would seem to be quite enough. But it isn't, the oil companies have always said, and Prudhoe Bay is not enough, either. That field,

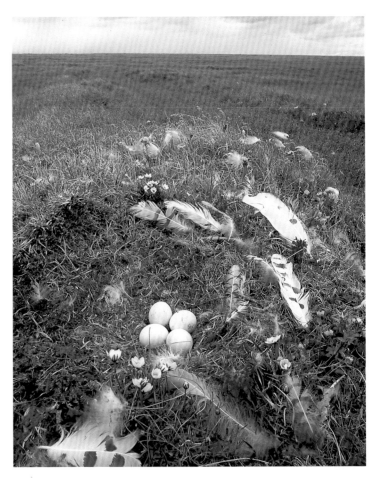

Wilderness at risk: at left, cottongrass blossoms ornament the banks of a tundra pond during the brief Arctic spring; at right is the spring nest of a snowy owl.

after ten years of full operation and five billion barrels of oil, is more than half gone, the oil companies say. But over on the Kuparuk River, in the West Sak Field some ten miles west of the principal complex at Prudhoe Bay, a recent discovery suggests that there might be another twenty billion barrels of oil waiting. That won't be enough, either, the oil companies say. They must be allowed to go into the 1002 Study Area, the oil companies say. Enough study, they say: time to drill.

The Interior Department agrees. In April 1987, Secretary of the Interior Donald Paul Hodel presented to Congress the final version of the study mandated by the Alaska Lands Act, "Coastal Plain Resource Assessment." He had read it, he said, and had come to his conclusion: "The Arctic Refuge coastal plain is rated by geologists as the most promising onshore oil and gas exploration area in the United States. It is estimated to contain more than 9 billion barrels of recoverable oil. . . . Based on the analyses conducted, public comment on the draft report, the national need for domestic sources of oil and gas, and the nation's ability to develop such resources in an environmentally sensitive manner as demonstrated by two decades of success at Prudhoe Bay and elsewhere, I have selected as my preferred alternative . . . making available for consideration the entire Arctic Refuge coastal plain for oil and gas leasing."

The portion of the assessment report that Hodel apparently read with greatest pleasure was the section that estimated in-place oil and gas resources in the 1002 Study Area. These resources, the report said, "are estimated to range from 4.8 billion to 29.4 BBO [billion barrels of oil] and from 11.5 to 64.5 TCFG [trillion cubic feet of gas]. . . ." How much of this oil could be actually recovered economically was open to question. The report settled on a "mean" (average) estimate of 3.2 billion barrels that might be economically recoverable, but also emphasized that the parameters of probability suggested two things: the existence of ". . .unusually large resources, or the possibility that there may be no exploitable petroleum resources in the 1002 area." Since this statement seems to say that there was an equal chance that there was *no* recoverable oil and gas in the 1002 area, Hodel's confidence seems a little inflated. It seems even more inflated when one turns a few more pages of the report and learns that "the chance of finding [an economically] recoverable field in the 1002 area is 19 percent." The report adds that this percentage "shows an exceptionally high potential for oil and gas." Maybe so, but this layman, at least, is puzzled over Hodel's statement that the 1002 area "is estimated to contain more than 9 billion barrels of re-

Caribou at risk: at right, a contingent of the Porcupine herd moves along the Kongakut River in the British Mountains during the post-calving migration; overleaf, another contingent of cows and calves slowly makes its way along the plain near the Jago.

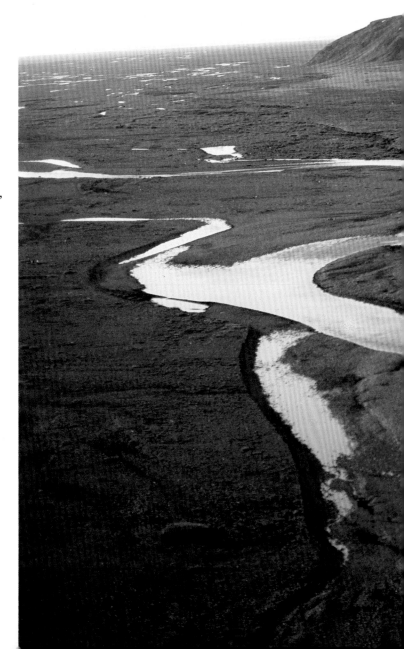

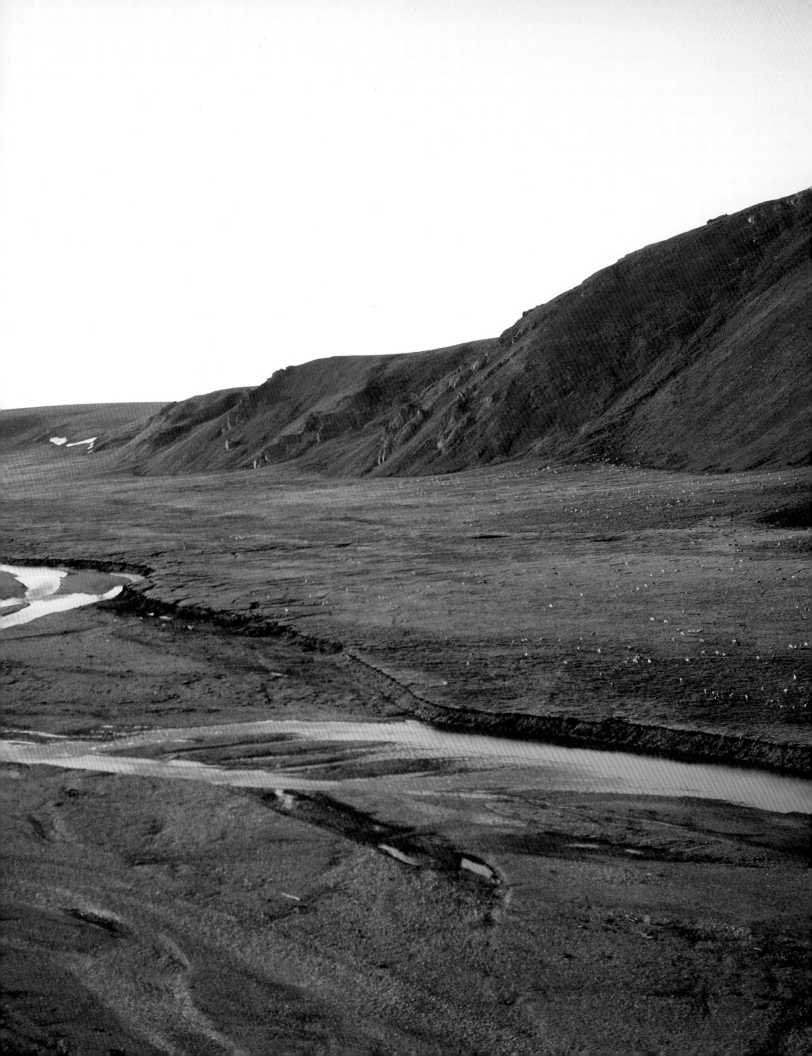

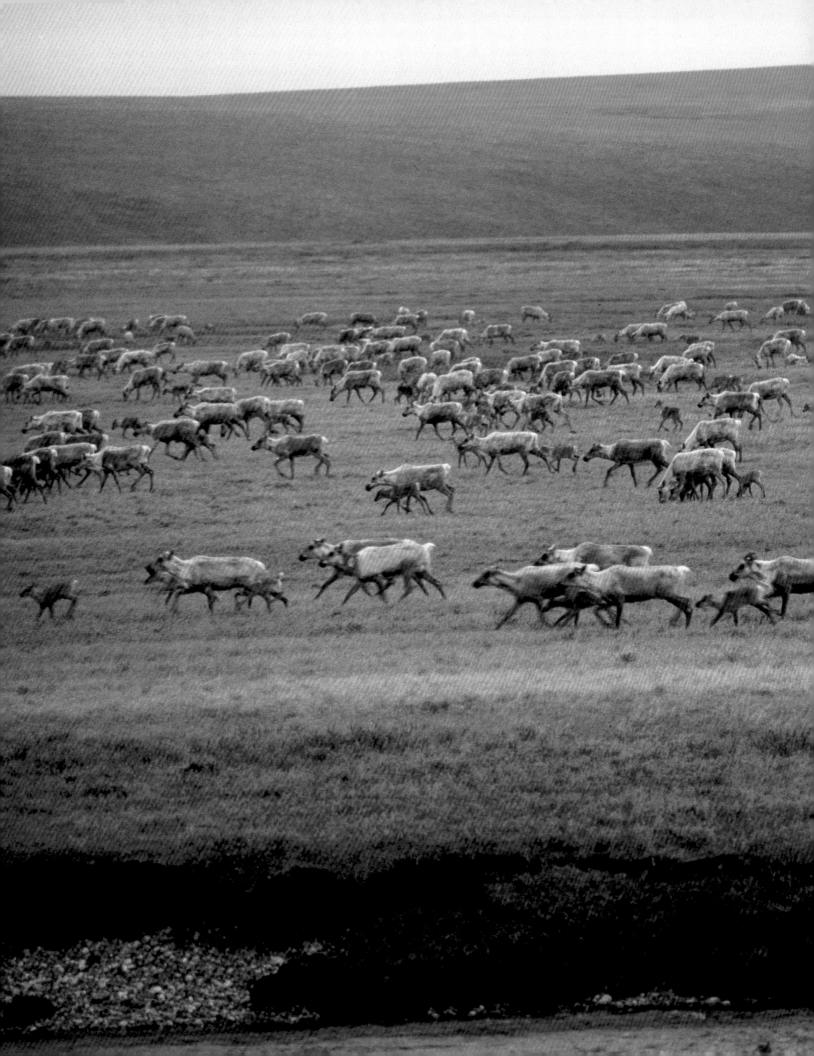

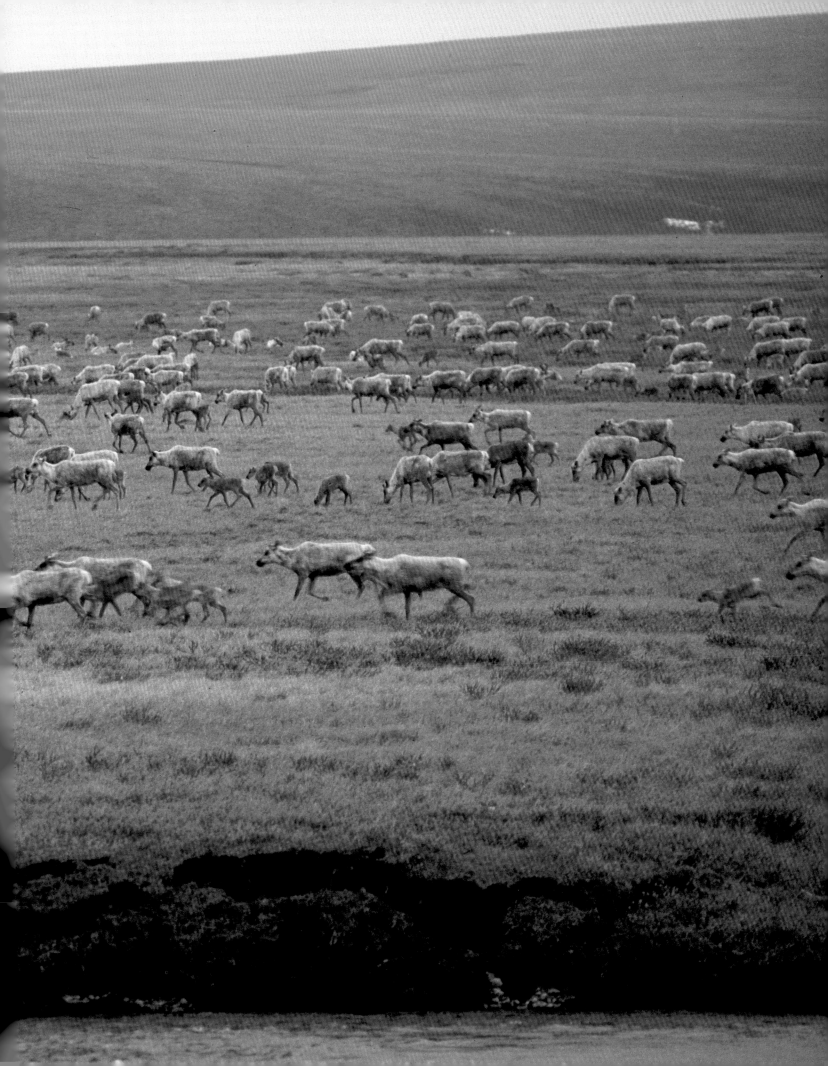

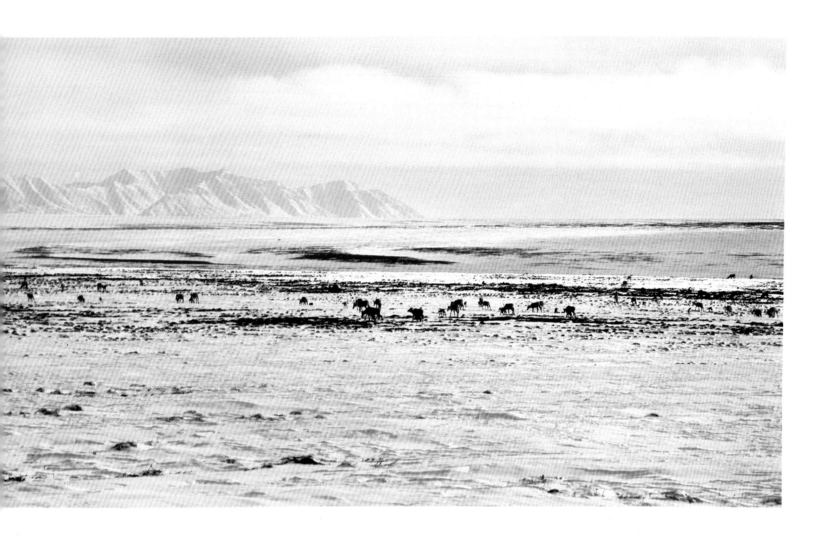

coverable oil. . . ." That isn't exactly what the report says. What the report says, exactly, is what I have cited above. Furthermore, in yet another section of the report, "The 1002 Area's Potential Contribution to U.S. Needs," the statement is made that "Recoverable resource estimates range from .06 BBO to 9.2 BBO." This seems to say that there *may be* "more than 9 billion barrels," not that there *are*; it also seems to say that there *may be* only 600 million barrels, which is just a little more than what is pumped up from Prudhoe Bay every year.

Well, no matter, the oil companies say. We still like the odds, they say. Besides, it's the government's duty to let us in there. "If Congress fails to authorize reasonable exploration and development in ANWR," M. G. Johnson, Manager of Exxon's Exploration Department, Offshore/Alaska Division, wrote to William P. Horn, Assistant Secretary of the Interior, on February 7, 1987, " . . . then there will have been an obvious breach of trust of the American people." Johnson couched his warning in a letter that accompanied Exxon's response to the draft "Coastal Plain Resource Assessment," issued in November 1986. Conoco Oil responded, too, and it felt much the same way: "Conoco agrees that the potential contribution of the oil production from the 1002 Area would

Above, cows, calves, and snow near Camden Bay, early summer; opposite page, a dry river bed in late summer.

make tangible positive contributions to the nation because it will create jobs, help to provide adequate energy supplies at reasonable costs, reduce our dependence on imported oil, enhance national security, promote a favorable balance of international trade, and provide state, local and federal revenues."

So, Katie, unbar the door and let us in. Salvation awaits on the other side. An oil company is an institutional species that feeds entirely on hope.

The issue is now joined, and is as neatly defined as any argument in the history of the modern conservation movement—and if the contention is not quite so colorful as it might be were the area under discussion a strip of the California coast, it is sufficiency intense to satisfy most of the demands of high drama. Given the stakes, it should be. As with so many environmental arguments, it is going to fall to Congress to make the decision: is it worth destroying forever the wilderness character of this exquisitely rare ecosystem for an amount of oil that, by the example set at Prudhoe Bay will, at best, last no more than a few years—assuming that it exists in quantities

that even come close to Donald Hodel's clearly unrealistic projections?

However bellicose that question may appear, it is in fact precisely the choice before Congress. For make no mistake: exploration and development of oil and gas fields in the Coastal Plain of Arctic Refuge will irredeemably and permanently (as humans measure time) transfigure those qualities that define it as wilderness in the first place—its natural systems and the landscape in which they function. No one, not even the oil companies, claim otherwise.

Consider, first, the landscape, and one does not have to go far (sometimes no distance at all) from the "Coastal Plain Resource Assessment" itself to discover the unsettling evidence. Seismic exploration would in many areas decrease plant cover, change the composition of plant species, compress the vegetative mat, cause "thermokarsting" (melting of permafrost near the surface), expose peat and mineral soils, and destroy fields of cottongrass hummocks. All of the above, in varying degrees and in varying places, certainly occurred during the study period mandated by the Alaska Lands Act, as heavy exploration vehicles tracked their way across the snow-covered tundra in winter. They were supposed to move only when there was at least six inches of snow to protect the tundra, but the operators often displayed a casual attitude, at best, toward the rule, particularly during the winter of 1984, when there was an unusually light snowfall. "When we suggested that they change their routes," a Fish and Wildlife Service staffer said in 1986 (he preferred to remain anonymous), "we got resistance. They'd try to cut corners. It wound up that we didn't enforce the six-inch guidelines, and eventually we saw that it didn't matter anyway—six inches wasn't enough to protect the soil." Significant damage resulted even from the limited exploration, and it seems unlikely that the situation would improve if oil companies are invited into the area for truly ambitious efforts.

Full-scale development would increase that impact geometrically. According to the report: "If the entire 1002 area were leased, subsequent oil development, production, and transportation activities, and associated infrastructure would eventually result in approximately 5,000 acres of vegetation being covered by gravel for roads, pipelines, airstrips, and other facilities . . . assuming all exploration is successful. Physical disturbances, such as erosion and sedimentation, thermokarst, impoundments, clearing, gravel spray, dust, snowdrifts, and pollution would alter the habitat values of many more acres."

"Infrastructure" is a good word, replete with implications. Here are some of them (and remember, this information comes straight out of the assessment report). The development of any discovered field would require, first,

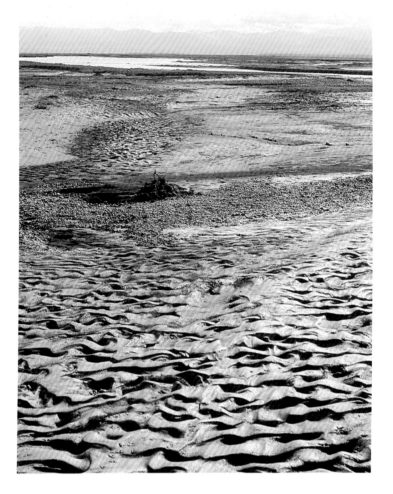

a temporary construction camp capable of housing and feeding up to 1,500 workers. These people would build the central production facility, a headquarters complex situated on a gravel pad five feet thick and anywhere from 20 to 100 acres in size; it would require from 180,000 to 900,000 cubic yards of gravel dredged from selected river sites. On this pad would sit various production facilities; living quarters for up to 500 people and an administrative office center; maintenance buildings, garages, storage tanks for fuel and water; an electricity plant, solid waste and water-treatment facilities, and a major pumping station. Depending upon the size of the discovered field, this central production facility would include its own drilling holes or service several drilling pads scattered in the land around it. Each of these pads, too, would be constructed of dredged gravel, would be 20 to 35 acres in size, and would include its own housing and production facilities. Assuming the discovery of a size suggested by Donald Hodel's 9-billion-barrel projections, it is entirely possible that a single fully developed oil field on the Coastal Plain

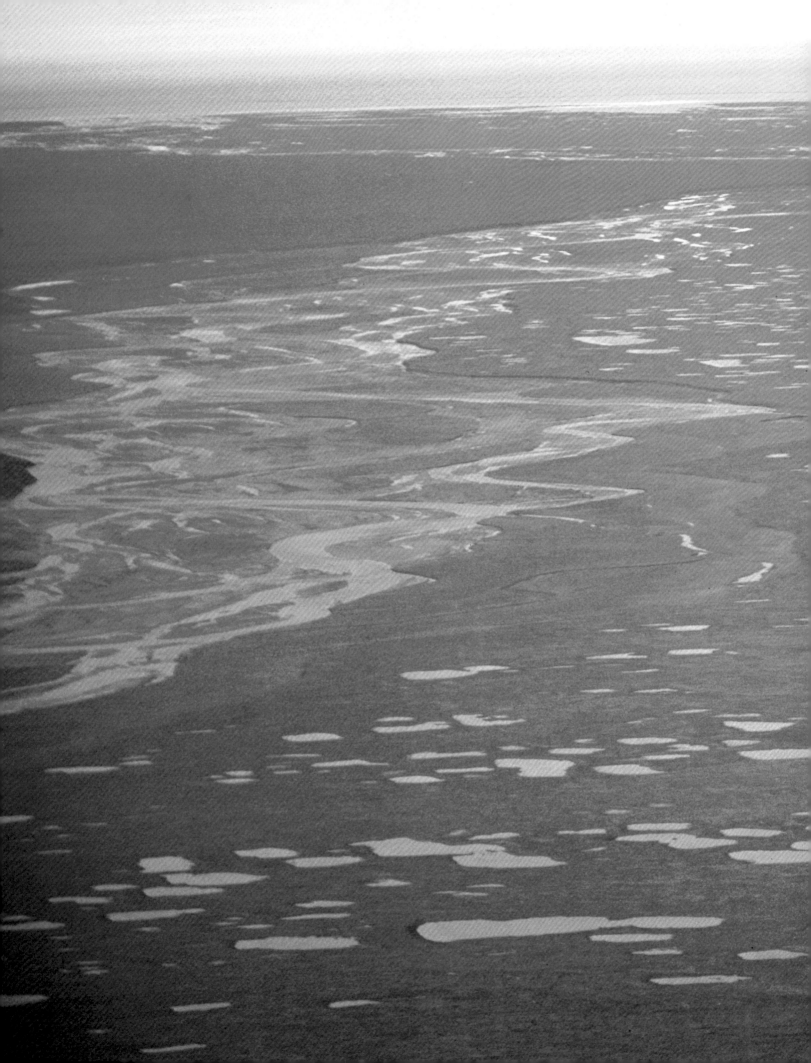

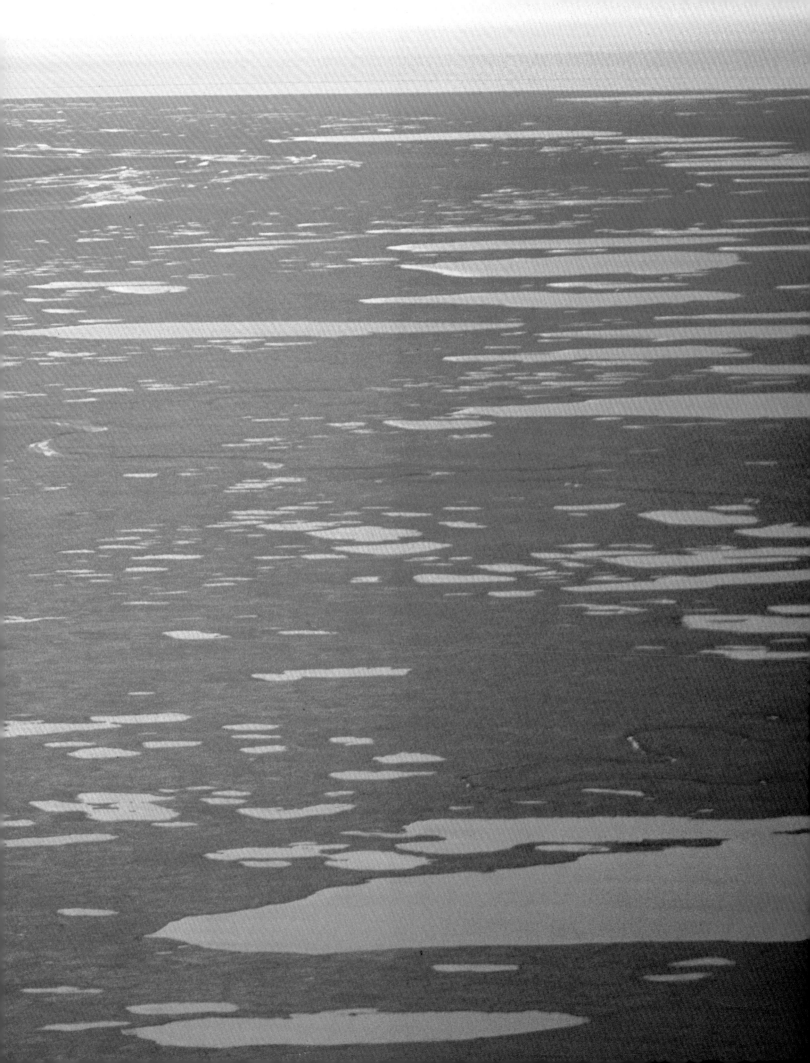

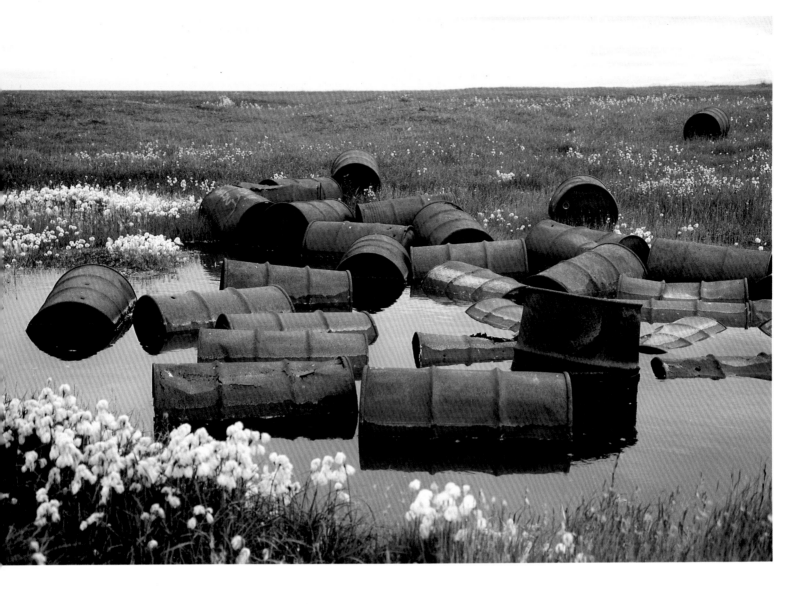

Previous spread: an overview of
the Coastal Plain, with the Jago
River braiding through the tun-
dra in the left-hand portion of
the picture. Above is some of the
detritus one can find in the "in-
frastructure" from earlier "explo-
ration" of ANWR. At left is a
tundra pond in the rain, and on
the opposite page is a northern
shoveler on a pond near the
Jago.

would include at least seven such drilling pads, each of them drilling and pumping from as many as fifty wells. The total area covered by such a complex, then, including a central production facility, could amount to as many as 345 acres.

That would not be all, of course. An airstrip for each major field would be necessary. This would be 5 feet thick, 5,000 to 6,000 feet long, and 150 feet wide, and would consume 250,00 cubic yards of gravel. Gravel roads would connect the airstrip, the central production facility, all drilling pads, water sources, and gravel pits. Each road would be 5 feet thick, 35 feet wide, and each mile would cover five acres of land and require 40,000 cubic yards of gravel. Along these roads would be elevated pipelines carrying gas and water from the central production facility to the drilling pads and oil from the drilling pads to the central production facility.

INFRASTRUCTURE. In what it calls a "hypothetical generalized development" projection on a full-scale leasing program, the assessment report says that there would be three major fields—one near the coast between the Canning River and the Sadlerochit, one further inland between the Hulahula and the Aichilik, and one north of that between the Aichilik and the Okpilak. The "sphere of influence" of these three fields would pretty much cover the entire 1002 Study Area. There would be a main pipeline running almost the entire length of the 1002 area over to the TAPS facility at Prudhoe Bay, crossing seven rivers in the process. Running with this would be a parallel road. Another major pipeline and road would cross about 30 miles of tundra and connect with the main line from the interior field. Each field would have a central production facility and an airstrip and the three would have a total of 25 drilling pads in operation. Seventy miles of roads and in-field pipelines would be in place. There would be two coastline port facilities (including seawater treatment plants), one west of Kaktovik in Camden Bay and another to the east between Manning Point and Angun Point. Infield roads and pipelines would make ten river crossing at various points.

If all this is sobering, it should be kept in mind that the above is what might be called a "best-case" scenario. Another projection, this based on the assumption of what the report describes as "ultimate development of mean conditional recoverable oil sources" (only 3.2 billion barrels of oil as opposed to Hodel's 9 billion), includes 160 miles of in-field roads and pipelines, four airstrips, seven large and four small central production facilities, 50 to 60 drilling pads, and twenty-five river crossings, together with 40 to 50 *million* cubic yards of dredged gravel taken from ten to fifteen "borrow" sites. This would be under a "full leasing program." There also is projected a "limited leasing program." This would eliminate the inland field

entirely, on the grounds that it would embrace the "concentrated calving area" of the Porcupine Caribou Herd (although there is in fact no "single" calving area—the animals are not that predictable). Development under this scenario would slightly reduce the figures above (there would be only six large and three small central production facilities, for example, and only 30 to 40 drilling pads).

Any way it is described, measured, calculated, projected, or defined, oil and gas development on the Coastal Plain of Arctic Refuge is going to assure the transformation of unquestioned wilderness into an enormous industrial park. The industry and the Department of the Interior insist that while this may be true, it is not necessarily evil. There are good industrial parks and bad industrial parks, they say, and it is possible to develop the Coastal Plain in an environmentally benign manner. ". . .I evaluated the potential effects of developing these potential hydrocarbon resources on the wilderness, wildlife, and subsistence values of the coastal plain," Hodel said in his formal recommendation in the assessment report. "My recommendation reflects my firm belief, based on demonstrated success at Prudhoe Bay and elsewhere, that oil and gas activities can be conducted in the 1002 area in a manner consistent with the need and desire to conserve the area's significant environmental values."

Well, what *was* the "demonstrated success at Prudhoe Bay and elsewhere?" The "elsewhere" would include active wells at Milne Point, Kuparuk, Lisburne, and Endicott, and exploratory wells at West Sak, Sandpiper, Seal island, Colville Delta, and other onshore areas as well as some in the Beaufort Sea. According to the Department of Interior's own figures, more than 17,000 oil spills have been reported in and around Arctic oil developments

since 1973; two of these exceeded 200,000 gallons each. The Alaska Department of Environmental Conservation reports that there were 521 spills in 1985 involving a total of more than 82,000 gallons; it further suspects that not all spills have been reported by the companies involved.

In addition to oil spills, there have been significant problems with wastes, particularly those stored in reserve pits, above-ground containment structures that are used to store used drilling muds, cuttings, and other wastes. These pits can contain up to 13 million gallons of such stuff, much of it containing toxic metals like arsenic, lead, manganese, chromium, and copper, as well as quantities of hydrocarbons and other additives. The pits are supposed to be impermeable, but oil companies admit that there have been numerous cases of leakage, as well as instances of "overtopping," when material slopped over the edges of the walls. Furthermore, millions of gallons of these wastes are regularly pumped out of the pits and into unlined tundra ponds, are spread over road surfaces, or are injected into the ground—all under permits issued by the Alaska Department of Environmental Conservation. In 1986 alone, more than 100 million gallons of pit wastes were disposed of this way. It is probably not the best idea anyone ever had. According to testimony prepared for the natural Resources Defense Council and Trustees for Alaska in October 1987, "Sediment concentrations of chromium and lead in ponds associated with reserve pits were found to be in the range of sediment metal concentrations typical of areas subject to heavy industrial pollution. Similarly, concentrations of total hydrocarbons in sediments in several ponds were consistent with levels observed in polluted coastal areas of the world." Under these circumstances, it is not as

surprising as it might otherwise be to learn that in 1983, in an incident one would more logically expect to see happen in New Jersey or some other heavily industrialized state, a company at work in the Big North was convicted of having spilled thousands of gallons while illegally storing more than 20,000 barrels of toxic chemicals.

Air pollution is no stranger. While no agency (and certainly no oil company) has devoted significant time and effort to the investigation of emission problems from oil and gas development in the Arctic, it is estimated that at least 63,000 tons of nitrogen oxides are getting dumped into the air every year—a little less than three times the amount spewed into the air of Washington, D.C. Things may well be worse than that, if the findings of a Congressional Research Service study of oil rigs in Southern California are applicable in the Arctic as well: the agency says that daily oil production from a single offshore oil rig may produce emissions equal in volume to those spewed out by 15,000 automobiles. If the rigs of Prudhoe Bay are doing the same, it would vindicate the Natural Resources Defense Council's contention that the field's air pollution compares to that of a major American city. Finally, both the Environmental Protection Agency and the Alaska Department of Environmental Conservation have expressed concern over the amount of particulate garbage that may be injected into the atmosphere by the oily black smoke from start-up and emergency oil and gas-flaring fires.

By far the proudest claim of the oil industry is that because of benign development habits at Prudhoe Bay and its environs, the area's resident caribou herd—the Central Arctic Herd—has flourished. It has indeed. Estimated at about 3,000 animals in 1970, the herd has now blossomed to some 18,000 head. On the other hand, it might be well to recall here Edward Abbey's remark that "uncontrolled growth is the etiology of the cancer cell." The truth is, the growth of the Central Arctic Herd is an unnatural phenomenon most likely brought about—as it so often is among deer populations in the Lower 48—by the parallel reduction in the number of wolves and bears, their principal predators, either by hunting activity (legal and illegal) or by the general industrial ruckus. Furthermore, the pairing of *tuttu* with progress here has not been without its complications. While bulls apparently have little reluctance to cross over or under the cunning road and pipeline underpasses and overpasses the oil companies have been required by government biologists to build, cows and calves quite often balk. And in an article in the September/October 1987 issue of *Defenders* magazine, Ken Whitten, a biologist for the Alaska Department of Fish & Game, articulated a major worry: "We feel there has been some displacement from calving grounds and disruption of movement at Kuparuk. In spite of that, the Central Arctic Herd has been able to fare well because even with the population growth, it is at a relatively

Like the trails of the caribou (see page 48), the etching that human beings make in the delicate hide of the Coastal Plain are all but permanent. The inscription at the right, scratched into the tundra just west of the Canning River in the 1960s, may still be there in another twenty years. At the lower left of the opposite page are wolf pups—who, with their parents, are increasingly threatened residents of the North Slope.

low density compared to the area it uses." What may happen if the herd grows another 600 percent in the next seventeen years is another question entirely.

Even this quick summary suggests that Hodel's air of reasonable confidence in the ability of industry and government to develop the oil and gas resources of the Coastal Plain with tender regard for the land and its wildlife is, at best, nourished entirely on hope and good intentions. By most other accounts (including, in many instances, the coastal plain assessment that Hodel signed), the impact on the life and landscape of the plain will be profound, no matter how it is measured or who is doing the measuring.

There almost certainly would be spills, the assessment report implies, and these spills "could kill waterfowl, particularly in lagoons where waterfowl congregate in large numbers. The effect on 1002 area populations could be major if a spill occurred in lagoons during peak molting, staging, or migration periods. Effects could also extend to other bird populations which migrate along the Arctic Refuge coast." Snow geese populations are highly sensitive to noise, and there would be plenty of noise, the report admits. This could result in a major displacement of geese from their normal habitat, with unknown effects on the health of the population. "Disturbance by vehicle traffic, drilling, human presence, or other causes could extend up to 3 miles from the source," the report notes. If such displacement occurred, it goes on, "habitat values could be reduced on as much as 45 percent of the preferred staging area in the 1002 area and 27 percent of the total preferred staging area in the Arctic Refuge." All bird species, to one degree or another, could be significantly affected by development, either through spills of oil and

hazardous wastes, noise disturbance, or the direct destruction of habitat.

So could the musk oxen, those hairy, shy relics of another time. "Major negative effects on the 1002 muskox population," the report says, "could occur from oil development, based on the possible displacement from preferred habitats." The denning habitats of polar bears could be changed forever, as could the foraging patterns of grizzlies, arctic foxes, and the wolves who come and go on the plain. Of all the large mammals, only the moose, which is a creature that can tolerate an astonishing degree of human activity in its life, would be essentially unaffected.

Not so the Porcupine Caribou Herd, although the precise level of impact is still uncertain. At one time, the wildlife specialists in charge of producing the relevant portion of the Coastal Plain assessment report thought they knew. The draft report stated outright that development would produce a "population decline and change in distribution of 20 to 40 percent," which could have meant a loss of more than 72,000 animals. Oil companies complained bitterly about this estimate in their responses to the draft, and the final plan released in April 1987 and endorsed by Interior Secretary Hodel says that any decline is "unlikely" and that the only effect on the caribou would be potential displacement from its normal calving grounds and migration routes. This differs sharply from the opinions of almost all other observers, who would be inclined to agree that the report's original projections were far closer to the facts of the matter. For survival, the caribou of the Porcupine Herd must have not only undisturbed calving grounds, but the freedom of movement to graze and to escape the maddening hordes of mosquitoes, botflies, and other insects that can make life nearly intol-

The eclectic village of Kaktovik, whose Native citizens have a stake in both the development of oil resources and the preservation of wilderness—a choice that has divided the town. "What you gonna do when the oil is gone?" one of the village's elders asks. Good question. No answer yet.

erable for adult caribou and can kill newborn calves. And pointing with pride to the survival rate of the Central Arctic Herd is irrelevant, these observers maintain. For one thing, as noted earlier, the Central Arctic Herd numbers only 18,000 nonmigratory animals occupying territory that is nearly as long and over three times as wide as that of the Coastal Plain; the Porcupine Herd contains 200,000 head dependent upon a smaller area. The impact of industrial development on that many animals in so little space could be devastating. "With the Central Arctic herd," state habitat biologist Dick Shideler told Tom Kizzia in *Defenders* magazine, "you've got 500 to 1,000 caribou crossing a road. The problem with the Porcupine herd is that you've got post-calving aggregations of tens of thousands of caribou, and nobody knows if they will behave the same way. In those big groups they tend to act differently, like a single superorganism. They've been known to stampede when spooked at river crossings. Heavy traffic on a road is the worst possible combination. We don't want to pen them in. The key to caribou survival strategy is to be able to move in different areas, depending on changes in vegetation, insects, and predation. They have to be flexible to survive."

The list of potential dilemmas could continue. It could include speculation on damages from the dredging of all those millions of cubic yards of gravel from streambanks, lakesides, and alluvial flats for the construction of drilling pads, roads, and airstrips. It could number among its items questions regarding the millions of gallons of seawater that might be pumped in from the Beaufort Sea and injected into wells and how that might affect permafrost integrity and subsurface water quality, or the millions of gallons of fresh water that would be needed for human use and sundry production processes. It could go on at some length, but the point would seem to be made: neither the land nor the wildlife would go undamaged by development.

What about the people, then? Not the estimated 6,000 imported workers who would compete with the caribou as the most populous large species on the Coastal Plain if full development got underway, but the Alaskan Natives, those who have been feeding from the garden of America's Serengeti for perhaps ten thousand years—what about them? The Athabascans of the South Slope, for the most part, have a great fear that *tuttu*'s numbers will be reduced and they oppose development as a direct assault on the physical and spiritual survival of their culture, which has been wedded to the traditions of subsistence hunting for hundreds of generations. So do the thousands of Canadian Natives who depend primarily on the Porcupine Herd for their sustenance. They would certainly give their endorsement to what the mayor of Arctic Village told the Interior Department when its intentions became known: "Don't do to the caribou what your ancestors did to the buffalo."

At first blush, it might seem that the Inupiat Eskimo of Kaktovik and environs would be inclined to feel the same. After all, they had always fought hard to protect the integrity of the land and coastal waters from which they had pursued a subsistence way of life, had celebrated when the Alaska Lands Act of 1980 had given all Natives a priority over others to hunt and fish, and had cooperated with the Athabascans in urging the signing of a Canadian-American treaty pledged to the protection of the Porcupine Caribou Herd (signed in fact in July 1987, and apparently considered too unimportant by Hodel and the Interior Department to be taken into account). But in 1971 Congress passed the Alaska Native Claims Settlement Act, a complicated measure that awarded the Natives of Alaska nearly one billion dollars, gave them the right to select some 44 million acres of otherwise unallocated federal land, and established village and regional native corporations. The village of Kaktovik got the surface rights to about 92,000 acres of the Coastal Plain adjacent to the town. In 1983, negotiations between officials of the Interior Department and the Arctic Slope Regional Corporation, Kaktovik's "parent" corporation, traded the government's subsurface rights to those 92,000 acres for some land in the Brooks Range the Interior Department wanted to add to Gates of the Arctic National Park. The regional corporation and the Kaktovik village corporation forthwith got into the oil business by letting Chevron go into the area to do some exploratory drilling—for a suitable fee, of course.

A well was drilled and capped and the drilling pad has since been abandoned (and Chevron is telling no one, including its Native "partners," what it found there). But some of the more entrepreneurial Natives of Kaktovik have decided that the future lies in oil development, not *tuttu* or bowhead whales or arctic char. They envision jobs and tax money and other good things that presumably would devolve upon Kaktovik. The government, from all indications, is willing to encourage this hope. Several years ago, it started negotiations with a number of village and regional corporations to secretly trade the subsurface rights to an additional 166,000 acres of Coastal Plain for scattered parcels of Native holdings in various wildlife refuges in the state. When the conservation community got wind of this, it sought a court decision to force the Interior Department to file an environmental impact statement on the trade and hold public hearings. While the conservationists waited for a decision, Interior Department officials went ahead with negotiations and planning, although Interior Secretary Hodel promised the Congress that he would not complete the deal without first obtaining its approval. It was no secret that several oil companies had made "arrangements" with native groups and would have gotten exclusive rights to drill and develop the area, had the deal gone through.

An article in the *Wall Street Journal*, no devotee of the conservationist cause, publicized the impending scheme, and in response to the consequent howls, assistant Interior Secretary William P. Horn allowed piously that the government had intended to make the agreement public all along and, besides, had no intention of doing anything without consulting Congress first. Certain members of Congress looked upon this with some cynicism and the House promptly passed legislation that would specifically block any such "megatrade," as it had come to be characterized.

Not all of Kaktovik's natives, of course, have succumbed to the Lorelei of petrodevelopment. While they might be tempted by the rosy picture of progress the oil companies and the Interior Department are slathering on the canvas of their own imaginations, many Natives have a terrible ambivalence about it all. "If they ask me, I say no," Tommy O. Gordon, a Native of the village, told writer Tom Kizzia in the summer of 1987. "But I can't stop it, I guess. You can't live around here without money any more. If there's no oil companies around here, everybody's going to be hungry." And Isaac Akootchook, a whaling captain as well as one of the most respected hunters and trappers in the village, says, "If oil people come, maybe the caribou are gonna move away. Who knows? When the oil is gone, what you gonna do?"

There are those who think it can be stopped. Chief among them is the Washington-based Alaska Coalition, an environmentalist aggregation that began to gather ammunition even before the issuance of the draft coastal assessment in November 1986. The Coalition is not a new entity. Made up of twenty-one individual conservation organizations, it is the modern incarnation of the outfit that proved so effective in engineering passage of the Alaska Lands Act of 1980. But the conservationists have not stopped there; each of the major organizations—including the Sierra Club, The Wilderness Society, the National Audubon Society, and the 4.7 million-member National Wildlife Federation (the latter two chose, for one reason or another, *not* to join the Coalition)—have launched their own education blitzes. *Wilderness*, the magazine of The Wilderness Society, devoted its entire Fall 1986 issue to the subject, and *Sierra, National Wildlife, Defenders,* and *Audubon* followed suit over the next year and a half, each of them digging into the story with increasing effectiveness. The Wilderness Society's particularly energetic Public Affairs Department pushed the story in all directions—newspapers, magazines, radio and television—and all organizations prepared and delivered exquisitely detailed and well-publicized analyses of the coastal assessment report and equally meticulous objections to Hodel's announced intentions. There were videotapes, slide shows, junkets to Arctic Refuge, a blizzard of brochures,

pamphlets, broadsides, and arcane studies, published and unpublished.

The struggle to influence public opinion, of course, was predicated on the theory that public opinion is the lever that moves Congress, and it was in Congress that the fate of the Coastal Plain would be decided. Even before Hodel's presentation of the final draft of the "Coastal Plain Resource Assessment," the mills of legislation began to grind. Congressman Morris Udall of Arizona was the first out of the box in 1986 with H.R. 4922, the Arctic National Wildlife Refuge Wilderness Act, which would have placed wilderness designation on the 1002 area. The bill did not move any distance to speak of in 1986, so it was renamed H.R. 39 (after the House bill that became the Alaska Lands Act of 1980) and reintroduced early in 1987. Congressman Don Young of Alaska countered with a bill to open the area to drilling. After several months of persuasion by conservationists, Senators William Roth of Delaware, Bill Bradley of New Jersey, and several other senators joined to introduce their own version of a wilderness bill in the Senate. Finally, Senators Frank Murkowski and Ted Stevens of Alaska, following Don Young's lead, devised a bill that would immediately open the 1002 Study Area to development, while Congressman Walter Jones and Lindsay Thomas introduced what they denoted a "compromise" development bill that was vigorously opposed by the Alaska Coalition.

And that, as it happened, was pretty much that for 1987. Bogged down in hearings, testimony, and a tangle of conflict, neither pro-development nor wilderness legislation of any sort escaped either house of Congress before it recessed. Today, as the presidential elections loom nearer and as members of Congress look nervously to the condition and integrity of their own seats, the question of what to do with the Coastal Plain of Arctic Refuge remains unresolved by the only body of government that has the power to protect or corrupt it. The problem is quite as neatly defined now as it was nearly two years ago, and none of the passion is gone. "We do not have to choose between developing the potential energy resources of [Arctic Refuge] and protecting wildlife resources," Donald Paul Hodel said in August 1987. "We can, and with congressional approval we will, do both." He meant it then as he would today. "It is a whole place, as true a wilderness as there is anywhere on this continent and unlike any other that I know of," Congressman Udall said at about the same time. "You cannot move industrial civilization into that place without losing what it is." He meant it, too.

And the land? The land has its own kind of meanings. The land is silent, waiting.

Setting up a shrill piping, Arctic terns wheel through the sky over Beaufort Lagoon at the continent's northern edge.

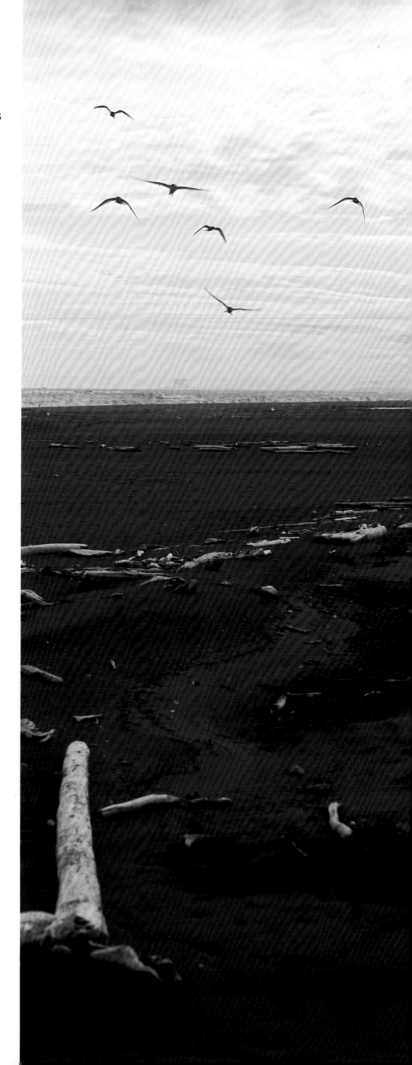

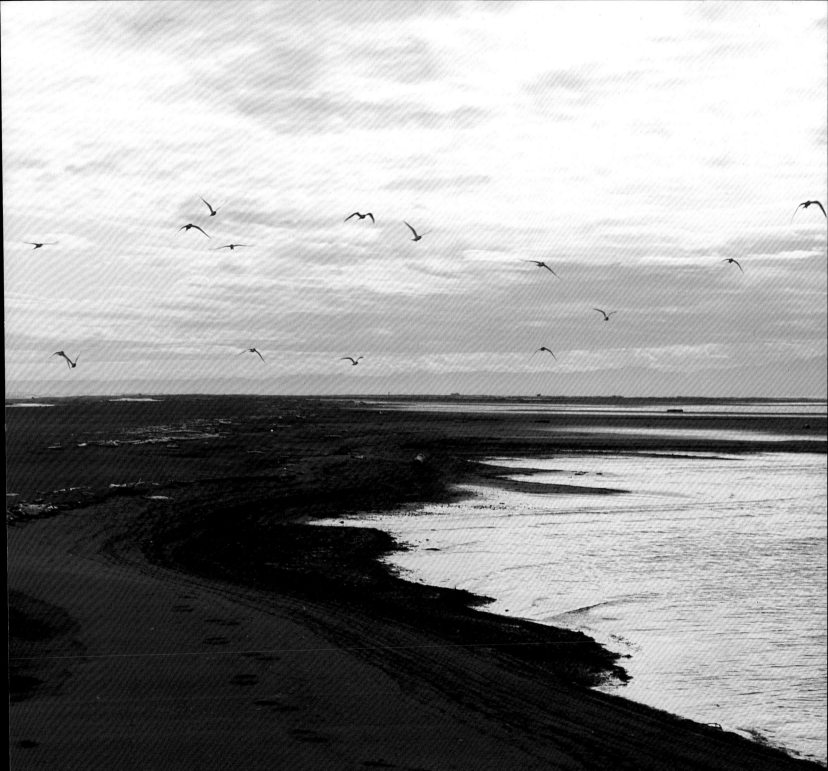

Epilogue

When the little herd of musk oxen gets a whiff of us and gallops in panic over the crest of a bluff, we turn with some reluctance back to the rafts. It is going to be a longer day than any of us had dreamed possible. As we paddle and push and struggle against the bitter wind that seems determined to keep us from ever reaching our pickup point, I achieve, all unbidden, a trancelike state in which reality is reduced to simple things—the moving paddle in my hand, the current of the river, the frigidity of the water that gurgles over the tops of my boots whenever it is necessary to get out of the raft, and the wind, always the wind. None of us has much to say, now, and we move down the river inch by crawling inch in a shared and exhausted silence. We have been on the move, including our rest stop, for thirteen hours before it is finally decided we cannot go any farther, pickup point or no pickup point. We straggle ashore, throw our tents together, and fall into our bags to sleep the sleep of the physically abused.

In the morning, under a gray sky, we crawl out of the bags and tents, load up, and get into the rafts once more. Happily, we are only a mile on the water before we spot the tundra patch where the plane is supposed to come. We pull in once more, and this time after the rafts are unloaded they are deflated and stuffed into the bags in which they came. We then wait, somewhat deflated ourselves. It is a long time before we hear the mosquitolike buzzing of the plane, then see it moving like a spot across the sky toward us. It is a tiny Supercub, capable of taking only one of us at a time, with equipment, back to Kaktovik. After the plane has landed, we learn that there have been some delays with other expeditions into the area and we will not be getting another plane for some time. It is only a twenty-minute flight into the strip at Kaktovik, the pilot assures us, so he can get a few of us in fairly soon.

I go out on the second trip, stuffed into the cabin behind the pilot like somethig crammed into a sausage casing. After bouncing across the gravel bar on its big balloon tires, the little plane leaps into the air with an intrepid whine, then levels off at eight hundred feet and heads straight for the enormous cups of the DEW-line antennae outside the town, relics of an age when the greatest fear we thought we needed to have was the prospect of being vaporized by Russian bombers.

To my right, I can see the distant cloud-ornamented crest of the Brooks Range; even from eight hundred feet, it still looks like a great wave trembling at the break. To my left, past the pilot, is the Beaufort Sea, the ice beginning to break up into huge sheets. Below me is the plain.

On the opposite page, the never-setting midnight sun tracks across the Arctic sky in a time exposure. Right, lesser snow geese rest on a tundra pond. Overleaf: the muted light at the top of the world wraps valley, mountain, and sky in a glowing cloak of mystery.

It is empty now, but I can see thousands of crisscrossing paths that have marked the passage of *tuttu* in the centuries past and will show them the way again when they finally return in all their thousands. In my mind's eye, I can see them there and can even imagine, in spite of the droning of the plane's engine, the sound of their clacking hooves and the muted communal roar of their grunting. The plain that stretches out on all sides between mountains and sea seems suddenly not a big enough place, seems inadequate to hold such a collection of life. And then I fantasize about what I might be seeing ten years from now if all the development that could be done here *is* done here. Pipelines, drilling pads, production facilities, the glimmer of waste pits, roads like gross distortions of caribou tracks reaching out, dust from trucks and ATVs, helicopters trammeling the air, the gaping holes of gravel pits, plumes of greasy smoke from flare-ups, buildings, towers, people. Industry. Pittsburgh-by-the-Beaufort-Sea. With all that, it does not seem possible that there could be also room for all the caribou. There will *be* few caribou here, I think. *Tuttu* and the landscape that has nurtured it for eons will be something rattling around in the coffin of history, victimized by an addiction.

"The United States has no oil policy, beyond a few local rules and regulations. It needs a national oil policy. Even more it needs a international oil policy. In the final analysis, such a policy will have to be determined by the Congress.

"It does not lie within the power of the Executive Branch of the Government to say what our oil policy

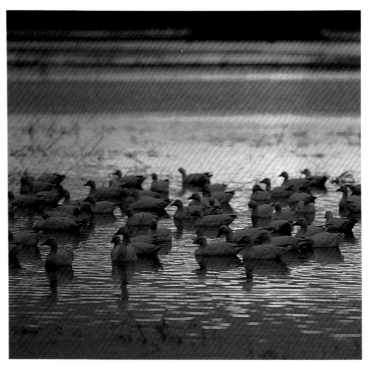

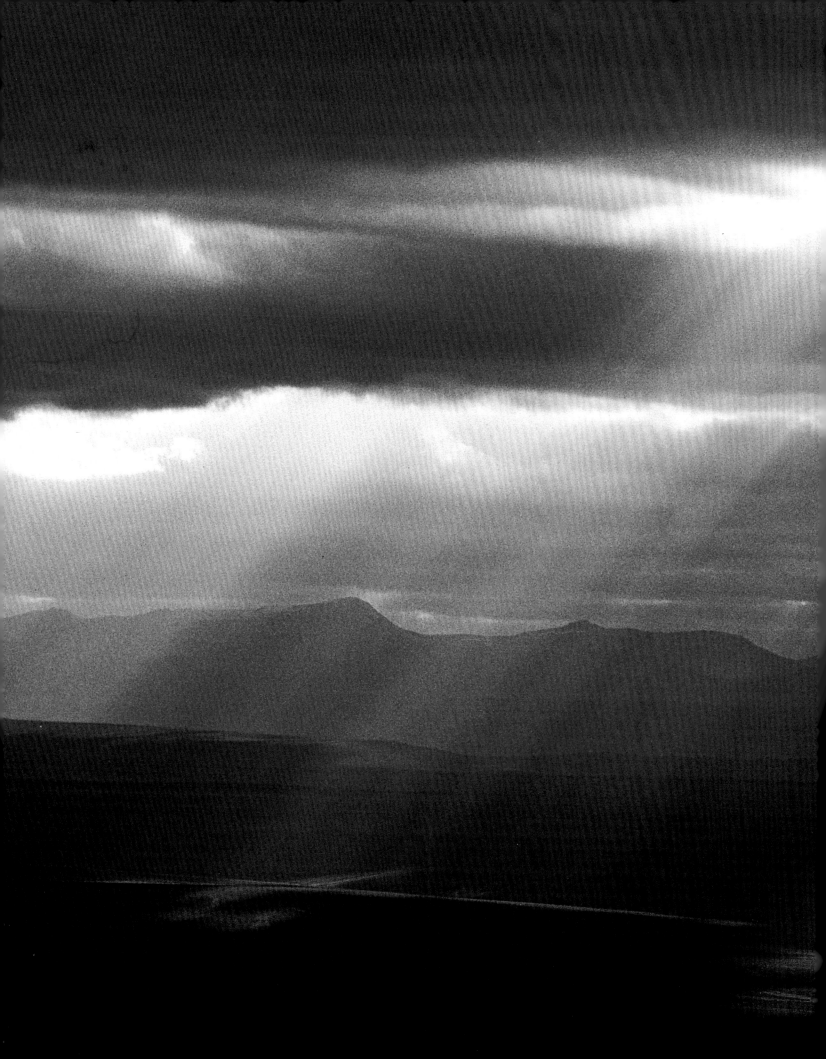

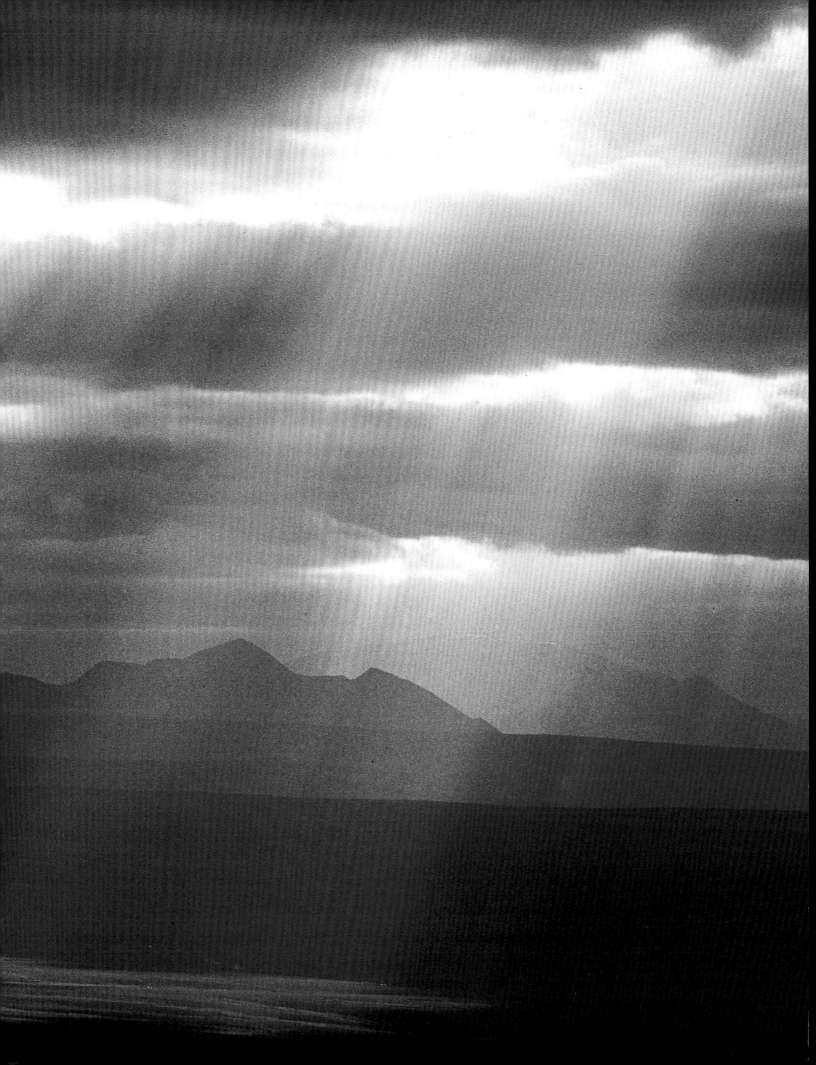

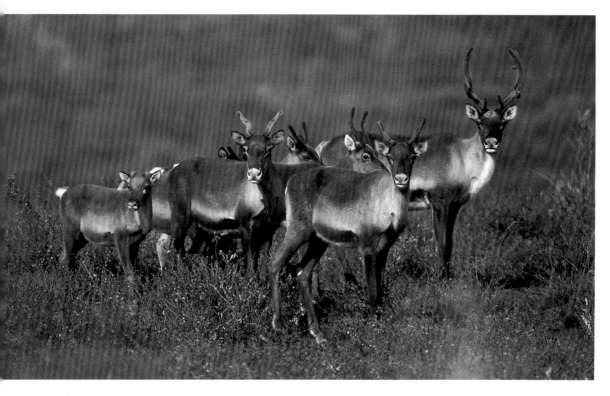

While humans debate the abstractions of beauty and utility, the creatures and the land they inhabit wait. At left, the creature with the most to lose: the caribou. At right, a view of the land where it may be lost: tundra ponds spreading across the Coastal Plain to the sea.

should be. It could make a recommendation and it is to be regretted that it has not done so because, from its place in the watch tower, it is in the best position of all to suggest a course of action. In the end, however, the Executive Branch would have had to go to the Congress to ask for the implementation of any plan that it might have evolved. So, in the end it is up to the Congress to say what our policy should be. There the issue lies as it has lain.''

Just so. Those words were written in 1947 by Harold L. Ickes, who had left his thirteen-year post as Secretary of the Interior just the year before. Forty-one years later, we still have no oil policy, though these days we would be more inclined to call it an energy policy that we don't have. Once, we almost had an energy policy, I remember. For a few brief years not too long ago, we had a Department of Energy that seemed dedicated to energy conservation and the serious development of alternative sources of fuel and power. There was talk of ethanol and biomass and passive solar energy and solar cell technology and electric automobiles and numerous other devices that could get us off the teat of petroleum. National speed limits were dropped to 55 mph. Mileage standards on automobile engines were put in place and enforced.

Today, the Department of Energy is a shell. The man who helped to make it what it is, the man who also gave the Pacific Northwest the nuclear fiasco of the Washington Public Power Supply System (WHOOPS, to the sardonic) just before moving to the national capital, was Donald Paul Hodel, the man who now would give us a new, improved version of the Coastal Plain of Arctic Refuge (it is important to keep in mind, I think, what and where he comes from). The Reagan administration has abandoned support of gas mileage standards, has supported the move to raise speed limits to 65 mph, has killed economic incentives and cut direct funding for the research and development of renewable energy resources, and has severely weakened all federal agency conservation and renewable energy programs and has managed to undermine many state programs as well.

No, we do not have an energy policy; what we have is an addiction, I think harshly—an addiction to oil, oil sucked up from wherever we can find it at whatever cost, oil consumed with the thoughtlessness of an alcoholic draining his last bottle of Ripple. "When the oil is gone, what you gonna do?" wondered Isaac Akootchook, the bemused Inupiat. I wonder too. I look down at the plain and consider the two scenarios that wait to be played out there. One is the caribou migration, even now beginning to filter across the mountains and soon to fill the land from the foothills to the sea. The other is the smoke and noise and soot of progress unrestrained, and it could start very soon, too. I consider that, and I remember what another Inupiat said. His name was Chuck McIsaac. He was a Native living over in Barrow in 1976, and he was reacting to all the technicolor promises being made by the oil companies who were offering a program for full development of the National Petroleum Reserve-Alaska. "Pow," Chuck McIsaac said. "Here's a package; you open it up and it eats you."

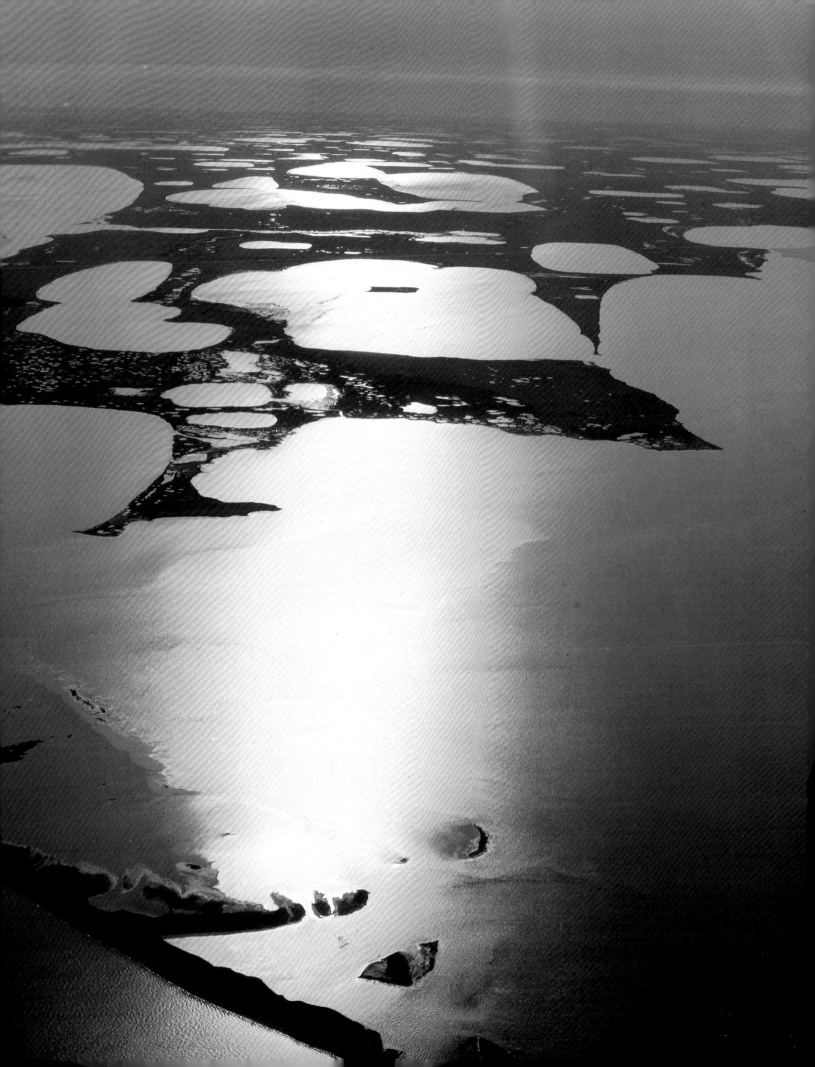

Copyright © 1988 by Aperture Foundation, Inc. "The Meaning of Wilderness" copyright © 1988 by Edward Hoagland. "The Fragile Magnificence" copyright © 1988 by The Wilderness Society. Photographs copyright © 1988 by the individual photographers Wilbur Mills and Art Wolfe. All rights reserved under International and Pan-American Copyright Conventions. Composition by David E. Seham Associates, Inc., Metuchen, New Jersey. Printed and bound in Hong Kong by Everbest Printing Co. Ltd.

ISBN: 0-89381-329-X
Library of Congress Catalog Number: 87-73574

The staff at Aperture for *Vanishing Arctic* is Michael E. Hoffman, Executive Director; Steve Dietz, Editor; Lisa Rosset, Managing Editor; Stevan Baron, Production Director; Tessa Lowinsky, Editorial Work-Scholar. Book design by Wendy Byrne.

Aperture Foundation, Inc., publishes a periodical, books, and portfolios of fine photography to communicate with serious photographers and creative people everywhere. A complete catalog is available upon request. Address: 20 East 23 Street, New York, New York 10010.

CREDITS

Photographs by Wilbur Mills appear on the jacket and on pages 2–3, 4, 6, 7, 9, 10, 11, 12, 13, 15, 16, 18–19, 19, 20, 21, 22–23, 24 (top), 25, 26, 29, 30–31, 31, 32–33, 34, 35, 36, 37, 38, 39, 40, 41, 42, 43, 44–45, 49, 52, 53, 54, 56, 57, 58–59, 59, 61, 62, 66–67, 68–69, 70, 71, 77, 80–81, 82, and 87.

Photographs by Art Wolfe appear on the endpapers, and on pages 5, 17, 24 (bottom), 27, 28, 46, 48, 50–51, 55, 60 (both), 63 (both), 64, 65, 72–73, 74 (both), 75, 76, 78, 83, 84–85, and 86.

The map on page 14 was designed and produced by Allison Frey, Wilma Frey Associates, Washington, D.C.

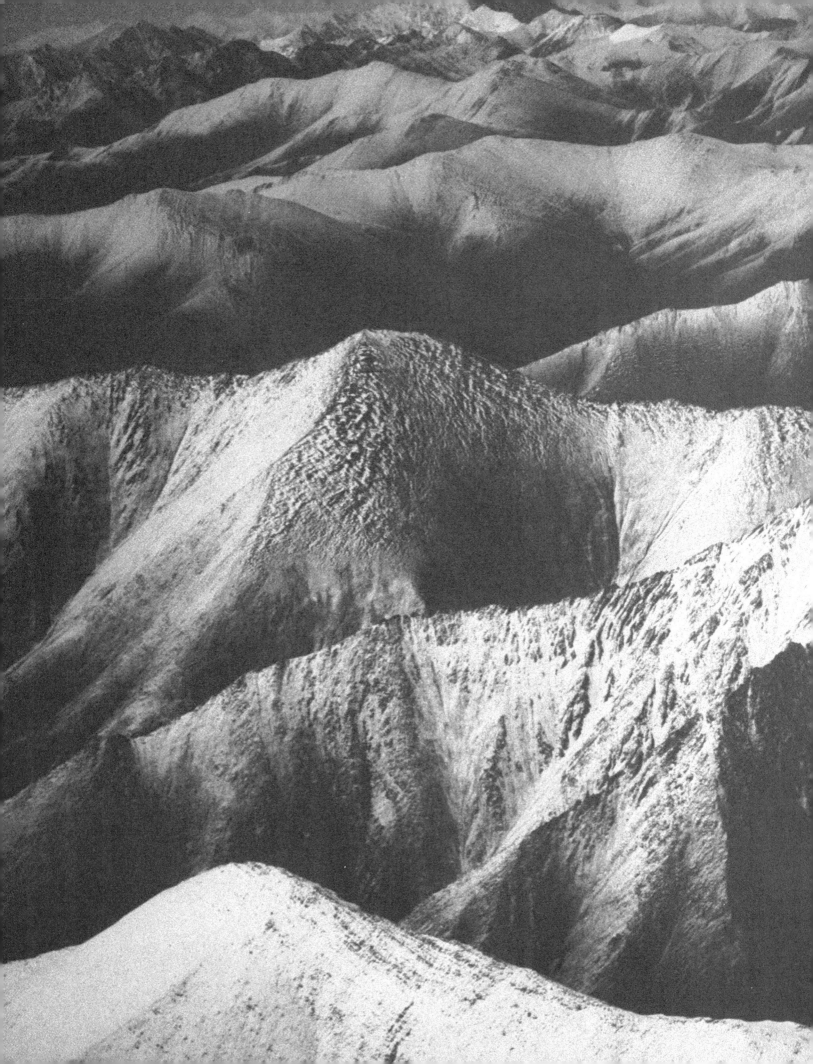